THE
BOOK OF
WILD FLOWERS

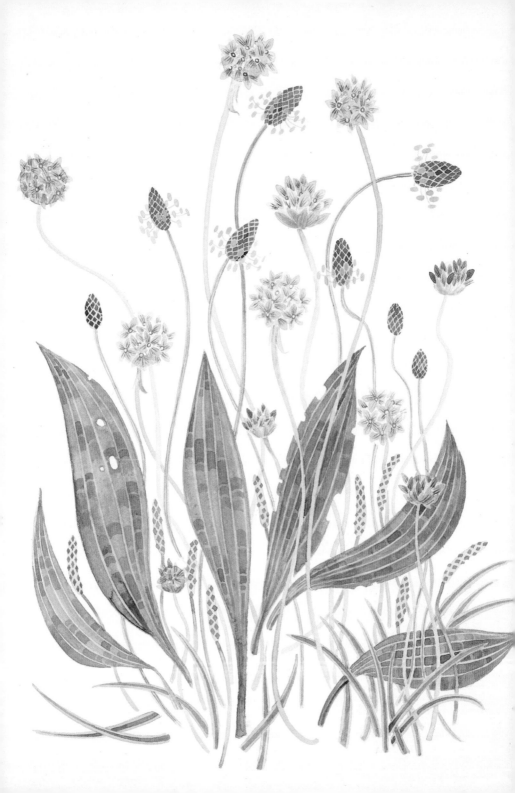

THE
BOOK OF
WILD FLOWERS

Reflections on Favourite Plants

———

Illustrated by Angie Lewin

Written by Christopher Stocks

Frontispiece: *Machair Study with Plantains and Thrift*
Watercolour, 2022

First published in the United Kingdom in 2024 by
Thames & Hudson Ltd, 181A High Holborn, London WC1V 7QX

Reprinted 2024

The Book of Wild Flowers: Reflections on Favourite Plants
© 2024 Thames & Hudson Ltd, London

Foreword and artwork © 2024 Angie Lewin
Text © 2024 Christopher Stocks

Designed by Simon Lewin

British Library Cataloguing-in-Publication Data
A catalogue record for this book is available from the British Library

ISBN 978-0-500-02706-6

Printed and bound in Slovenia by DZS-Grafik d.o.o.

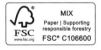

Be the first to know about our new releases,
exclusive content and author events by visiting
thamesandhudson.com
thamesandhudsonusa.com
thamesandhudson.com.au

CONTENTS

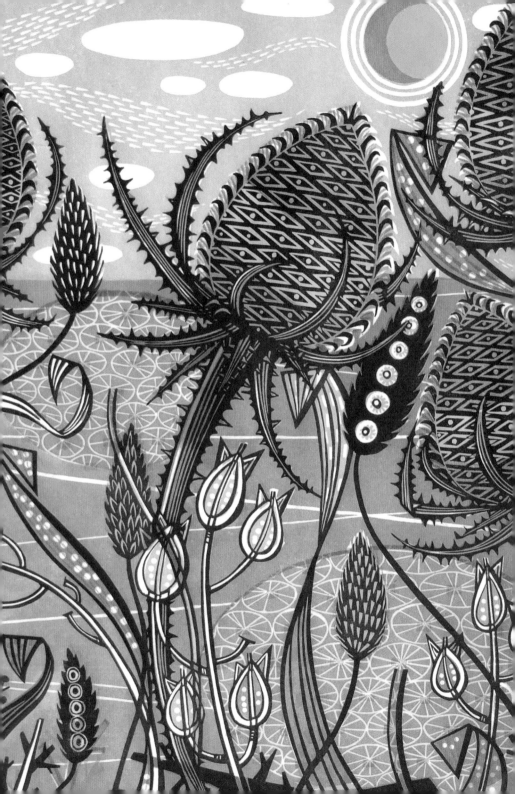

FOREWORD

STEM, LEAF AND FLOWER

ANGIE LEWIN

This is a very personal collection of wild-flower portraits. These long-familiar plants anchor me in the landscape, evoking specific places. I regularly visit wild, timeless, often exposed environments where seemingly insignificant plants are integral to the character of the place. The graphic silhouettes of the umbels of alexanders take me back to my earliest walks when my husband, Simon, and I first moved from London to the North Norfolk coast. Now that I live in Scotland, devil's-bit scabious and yellow rattle define my walks by the River Spey, close to my home and studio. Thrift and kidney vetch remind me of the Atlantic coast of the Outer Hebrides, which I visit each year. I'm instinctively drawn to the unmistakable bright yellow flowers of a dandelion growing opportunistically in a crack in a city pavement, or to sea plantain clinging valiantly to wind-battered and lichened coastal rocks.

Autumn Teasels (detail)
Linocut, 2019

Page 9: *Plantain Sketch*
Watercolour, 2004

These plants are those that I love to sketch and include in my watercolours and prints. Wild carrot often suggests a linocut or screenprint. Fritillaries appear in my watercolours as I make patterns from the many shades of their chequered petals. I'll draw the seedheads of poppies filled with their thousands of tiny black seeds in preference to their translucent red, papery petals which will have initially caught my eye in the verges of Norfolk lanes. I try to capture what defines the essence of a plant for me.

Through the seasons and even day by day, the plants that capture my attention change. On a favourite walk on North Uist one day, wild carrot will be my focus. Then, returning a few days later, I will spot campion and corncockle dotted through the machair (a type of fertile coastal grassland) or a mass of marsh cinquefoil growing by a lochan. On another visit, primroses carpeted the machair around the lichen-encrusted gravestones of a tiny cemetery perched above a beach of white sand.

My home is in a rather wild and exposed spot, a once derelict croft cottage and steadings on the side of a hill with grouse moor above. I leave the boundaries of the garden to grow naturally, planting native species to tie in with views to the hills and mountains beyond. I cherish the first snowdrops and primroses when they appear beneath the hedges in spring, and listen to the curlews and lapwings as I sketch them outdoors or in the studio. As ramsons emerge under the trees, I anticipate their umbels of starry white flowers and contemplate which pot I might place them in for a painting or print. When the shiny, bright red new growth on common dogwoods *(Cornus sanguinea)* appears, it creates a vibrant

contrast with the older stems encrusted with chalky green and bright orange lichens. I'll often include a branch in a painting.

In the way that weeds or self-seeded plants creep into my flowerbeds, I will add additional elements – a flower stem, fern frond or feather, a lichened twig or a twist of bladderwrack into my still-life composition as my print or watercolour progresses.

Christopher Stocks is also an obsessive plant-spotter. Although he lives on the south coast of England, we encounter many of the same wild flowers on our walks, and we'll often meet to seek out cyclamen and snowdrops in a London churchyard.

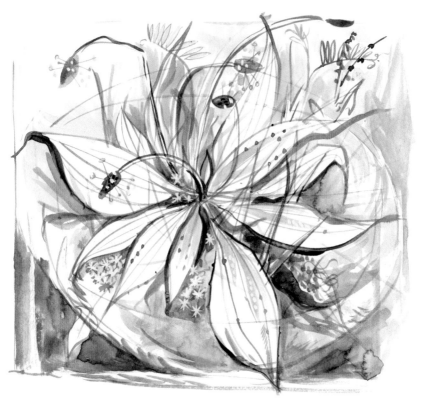

INTRODUCTION

THE WILD FLOWERS WE SHARE

CHRISTOPHER STOCKS

What makes a wild flower wild? On the one hand, any flower growing in the wild, and that hasn't intentionally been planted, could be said to be a wild flower, whether it's a dandelion, a daisy or Japanese knotweed. Another, more purist definition would claim that only native flora counts as wild; in this case occurring naturally, and pre-dating Britain's first human arrivals. Either seems to me to be a plausible description, although the purist approach also has its drawbacks, since some of Britain's best-loved wild flowers, such as snowdrops and snake's-head fritillaries, may not be native at all.

Like Angie Lewin, I've been admiring wild flowers all my life. My parents first taught me how to look closely at the natural world. When I was a boy growing up in Yorkshire, local farmers

Ravilious, Seedheads and Feathers (detail)
Watercolour, 2020

Page 13: *Plantain, Summer Shore*
Screenprint, 2022

were still grubbing up hedgerows, burning stubble and drenching their fields with herbicides and pesticides, but even then there were overlooked corners of common and woodland where orchids and wild daffodils could be found. Dorset, where I've lived for the last twenty-five years, has been luckier, and its flora and fauna are far richer as a result.

Working on this book together, it's been a surprise to discover that, despite living at opposite ends of Britain – Angie in the far north-east of Scotland, above the Cairngorms National Park, me on an almost-island off England's south coast – we see many of the same flowers through the year. This has less to do with climate than with habitat: as lovers of Angie's work will know, she spends a lot of time drawing flowers on the coasts of Scotland and Norfolk, while my regular stamping grounds are the cliffs of Purbeck and Portland.

Britain is a small country, so wherever you live, wild flowers are unlikely to be far away. Thanks to stricter regulation and the work of conservation charities, their habitats are less threatened now than they were a few decades ago, although they still deserve our care and protection. Never pick wild flowers, however tempting it might be when you're deep in a bluebell wood or a primrose-fringed lane: it's illegal to dig up any wild flowers, or to pick them if they're in a public park, on National Trust property or in a nature reserve. Several dozen are further protected under the 1981 Wildlife and Countryside Act, making it a criminal offence to pick them at all. Better by far to draw and photograph them where they grow.

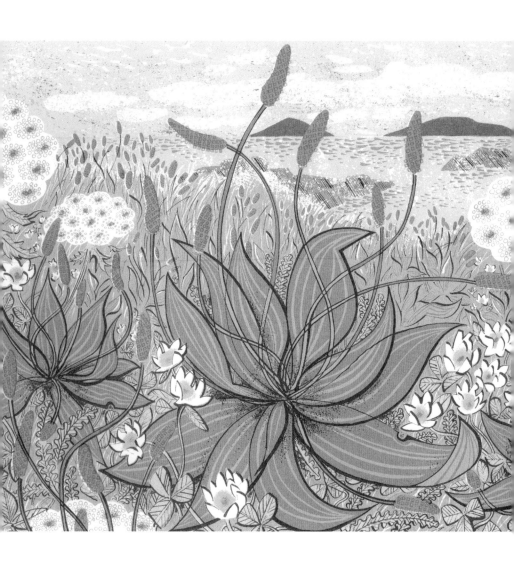

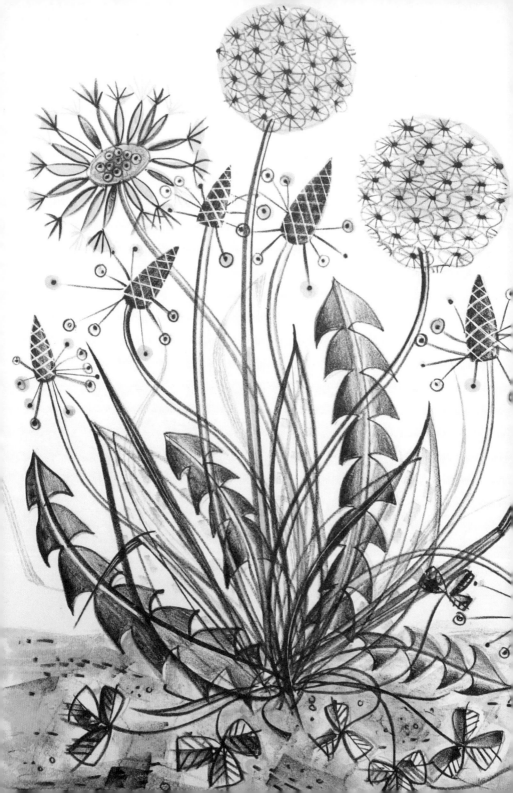

DANDELION
Taraxacum spp.

At a certain point each spring, the eggy yellow of dandelions can be the commonest flowers of all. I've seen country hedge banks so thickly covered with them that the entire roadside shines gold. They are, of course, a garden weed, popping up apparently overnight in neglected corners, and they don't seem to be especially welcome even among those who plant 'wild flower' meadows, but they're an important source of nectar for many insects, while their seeds are eaten by birds and their leaves by rabbits and pigeons.

Dandelions are great survivors. Individual plants can live for well over ten years, and send down a tap root up to two metres long, which makes them well nigh impossible to dig up. Break the root off and they can regenerate, sending up new plants to replace

By the Track
Lithograph, 2013

the lost crown. Each plant can produce an average of around 3,000 seeds, most of which don't require pollination to be fertile, and are ready to start growing in little more than a week.

Although they're one of the few flowers that almost everyone can identify, dandelions are actually one of the most puzzling plants on the planet. They may be instantly identifiable by the most amateur gardener, but these apparently simple flowers are actually anything but. For, while they might look the same to you and me, there isn't just one kind of dandelion; there are around 230 superficially similar-looking yet genetically distinct 'microspecies' in Britain alone, and it's quite possible to discover eighty to a hundred different types in a single locality, assuming you know what you're looking for.

Even the Botanical Society of Britain & Ireland admits that, along with hawkweeds and brambles, dandelions are 'the most challenging genus British and Irish botanists encounter'. Perhaps these intriguing plants offer a good illustration of why, at least sometimes, ignorance can be bliss.

Dandelions
Linocut, 2003

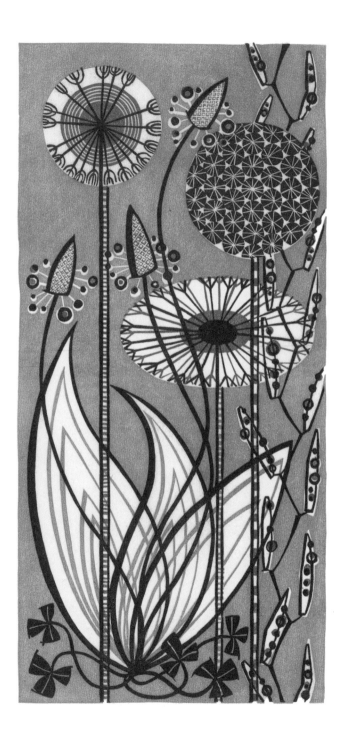

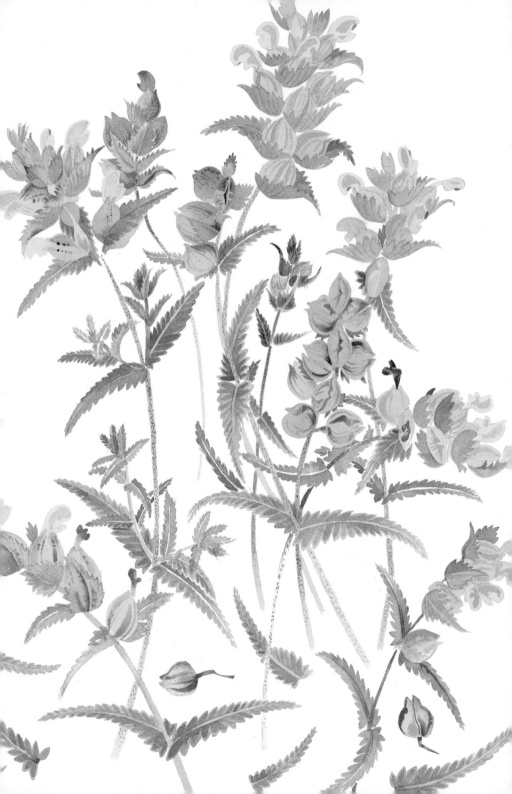

2

YELLOW RATTLE
Rhinanthus minor

Yellow rattle grows luxuriantly on the Dorset clifftops, in short, rabbit-nibbled turf, first appearing in late spring as an angular rosette of narrow, finely toothed leaves flushed with red. After that they fade from notice for a while, as the grass grows around them, but in early summer their hooded yellow flowers begin to open, and suddenly they seem to be everywhere. They look rather like dead-nettles, and could easily be mistaken for yellow archangel (the appealingly named *Lamium galeobdolon*), although in fact they're unrelated. Until 2004 yellow rattle was in the Scrophulariaceae family, along with mulleins and figworts, but DNA analysis has revealed that it is more closely related to eyebright, cow-wheat and broomrape, all of which belong to the Orobanchaceae – a large family of partly or fully parasitic plants. This makes sense,

Yellow Rattle, Knockintorran
Watercolour, 2021

since yellow rattle is also partly parasitic, with specially adapted root-like structures called haustoria that penetrate the tissues of the grasses around them and sap them of their nutrients. Unlike true parasites, however, rattle also has fully functional green leaves and synthesizes its own chlorophyll, so you could say that the energy it steals from grass is a back-up supply. It's also pickier than some other parasites, attacking only grass, and grows best in open, sunny conditions.

Its flowers don't last long, although they keep their shape as they turn into dry, papery seed-cases, and it is these that give yellow rattle its name. Brush through them as you walk and you'll see (or rather hear) why, because inside each seed-case is a stack of disc-shaped seeds, which rattle when they shake. When fully dry the cases split open and the seeds spill out, spreading around in early autumn and germinating the following spring.

For centuries rattle (along with other grass-feeding parasites) was understandably regarded as a yield-reducing weed of pastureland, and was ruthlessly removed or treated with herbicides. In recent years, though, it has been reinvented as the wild-flower gardener's friend, for exactly the same reason that farmers dislike it. Wild-flower meadows may look beautiful, but the conditions that give rise to them are very different from those found on the average household plot, as thousands of disappointed gardeners have found. Most of us have spent years of our lives improving the soil, adding organic matter and various kinds of fertilizer, but the majority of wild flowers have evolved to survive in much harsher conditions, on thin soils with little nourishment and often not much water, where they can successfully coexist with wild grasses.

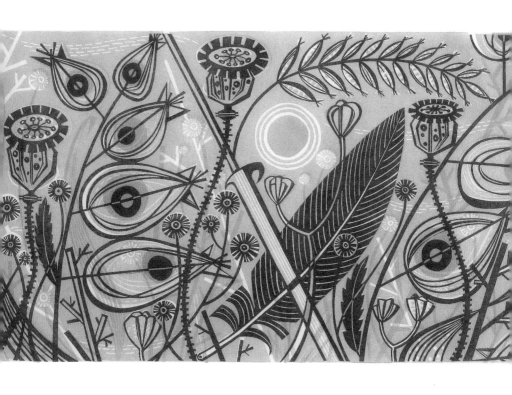

Yellow Rattle
Linocut, 2009

Wild flowers will, of course, grow happily in the much richer, better-watered soils of a domestic garden, and so will most kinds of grass – and under these conditions grasses have the evolutionary advantage, out-competing the majority of wild flowers apart from such familiar friends as daisies and dandelions. Thus the crushing disappointment experienced by so many enthusiastic gardeners after scattering handfuls of wild-flower seed across their lawn, when not a single flower comes up. Sadly for time-poor householders, creating a wild-flower meadow is more demanding than one might think – but this is where yellow rattle can help.

The most effective way to mimic a natural wild-flower meadow is to reduce the fertility of the soil. One way to achieve that is physically to scrape off the richer topsoil, leaving a thin layer of poor-quality subsoil in which to plant your seeds. It's a mucky, back-breaking exercise if you do it yourself, and can be an expensive one if you employ someone else to do it for you, but there is an easier way, even if it takes longer overall and isn't quite so effective. Sow plenty of yellow-rattle seed in your lawn in the autumn after the grass has been cut, rake it in and allow it to flower and set more seed for two or three years, and – all being well – it will gradually sap the vim and vigour from the grass, enabling wild flowers to gain a foothold and then thrive.

The alternative, of course, is to do something far easier and more authentic: forget about your garden, put on your walking boots and visit some wild-flower meadows in the wild.

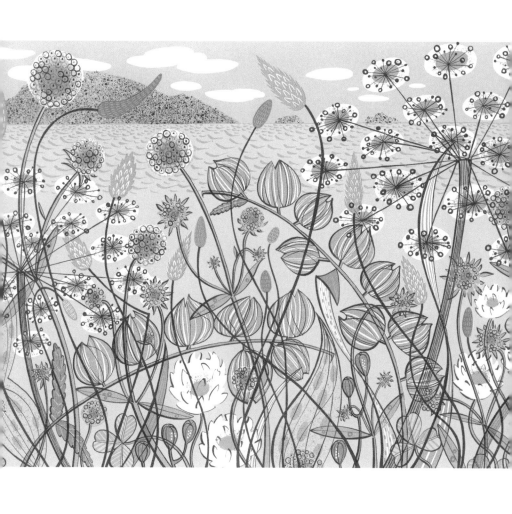

Machair
Screenprint, 2019

Overleaf: *By Green Bank* and *Late Summer Spey*
Mixed-media working drawings, 2009

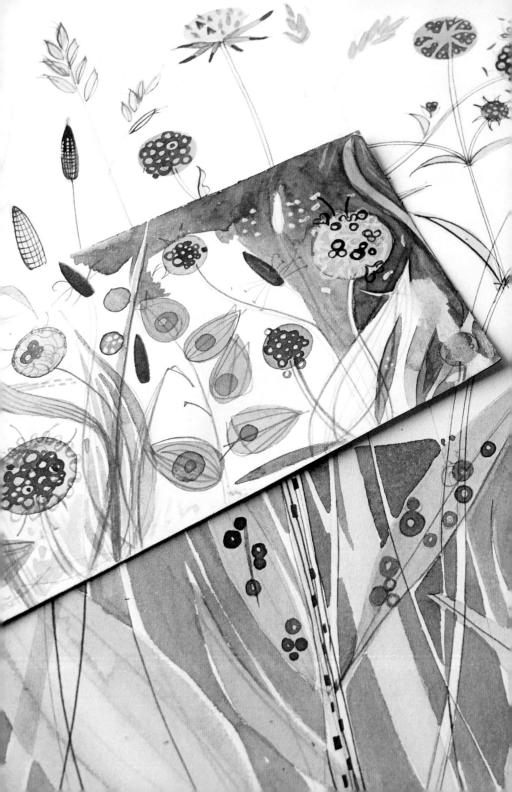

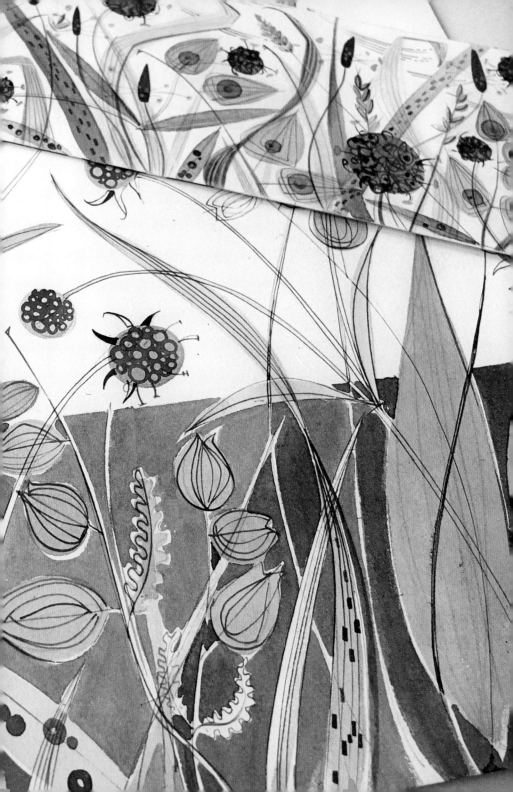

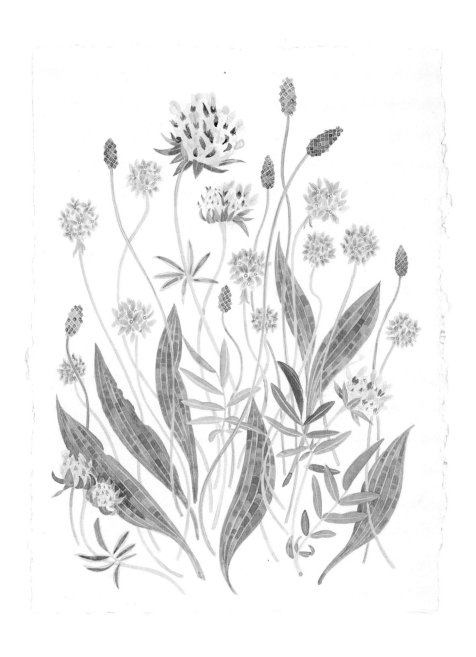

Machair Study with Kidney Vetch
Watercolour, 2022

3

KIDNEY VETCH
Anthyllis vulneraria

With its fluffy flowers looking rather like yellow clover, this widely spread, drought-tolerant member of the pea family is found in lowland areas right across Britain, especially on limestone soils, cliffs and sand dunes, where it scrambles around very happily. Its clustered flowerheads are unusual in that half of them are generally in bloom while the other, browner half have already gone to seed. Although its native habitats have declined over the last century, kidney vetch has also spread to new areas thanks to cars: it's often included in wild-flower seed mixes, and thrives on limestone chippings along the sides of roads. And where you find kidney vetch, you'll also find small blue butterflies (*Cupido minimus*), which are entirely dependent on it for their food.

4

DEVIL'S-BIT SCABIOUS
Succisa pratensis

Not far from my mother's village in north Dorset is a nature reserve that's particularly renowned for two things. In early summer its scrubby thickets are haunted by nightingales, whose choppy sequences of liquid song – generally first thing in the morning and late in the day – can be almost deafening close to. Nightingales, sadly, are rare these days, but far rarer are the butterflies that are the reserve's other claim to fame.

The beautiful marsh fritillary butterfly (*Euphydryas aurinia*) was once fairly widespread in the UK. Not so now. A century of development, pesticides, herbicides and large-scale agriculture has drastically reduced the habitats in which they once thrived, along with the plant on which, at some point during their evolution,

Devil's-Bit Scabious and China Cup
Watercolour, 2021

they staked their survival. This plant is the devil's-bit scabious, the blue-mauve flowers of which offer plentiful nectar and pollen for a host of hungry insects.

Unlike the marsh fritillary, this scabious is still relatively common on poor soils, in damp meadows, marshes and along woodland rides. Its pincushion-shaped blooms are held on tall, wiry stalks and can be seen between June and October, above a dishevelled rosette of narrow, pointed leaves shaped like palette knives. Although its flowers look rather like sheep's-bit and field scabious, they're not closely related; devil's-bit and field scabious are related to teasels, but sheep's-bit belongs the campanula family.

The marsh fritillary butterfly relies on devil's-bit scabious not only for its flowers, but also as food and shelter for its caterpillars, which spend their entire existence on the plant. Several hundred eggs are laid on the underside of the leaves in early summer, and about a month later the newly hatched caterpillars weave a web around the leaves and themselves, which gives them some protection from birds and other predators. Over the next few months they grow and shed their skins three times, before weaving another, tougher web in which they spend the winter, shedding their skins again to enter the fourth 'instar' stage of their life before settling down to several well-earned months of hibernation. When they wake up again, around February, they make yet another web – only this time it's more like the instar version of a daybed. Rather than hiding inside it, they sit on top, where they bask in the early spring sun. They can do this because by this point they have been transformed from vulnerable, smooth-bodied grubs into rather sinister-looking black caterpillars with a

By Green Bank (detail)
Screenprint, 2009

thick coat of spiny-looking hairs. They're now so unpalatable that they no longer need the web to protect them from predators, and their black coloration helps them to absorb what little heat is in the air.

During April they shed their skins twice more, growing bigger and fatter with a scattering of white spots. It is at this point that the colony breaks up and its caterpillars munch away at the devil's-bit scabious on their own. In late April or early May they make themselves a brightly coloured cocoon, to emerge later in May as a butterfly – in the case of female marsh fritillaries, already bearing eggs, which are often fertilized in their first day on the wing. The fertilized eggs, of course, are then laid on the underside of a devil's-bit scabious leaf, and the whole year-long process begins all over again. No devil's-bit scabious means no marsh fritillary butterflies, making it a wild flower to treasure.

And its rather puzzling name? The scabious part is thought to derive from the plant's use as a herbal remedy for scabies (both words derive from the Latin *scabere*, to scratch), but it was also considered to be an effective ingredient in cough mixtures, as well as in treatments for fever and bruising, while its leaves yield a green dye. This status as an all-round wonder-herb seems to explain the 'devil's-bit' part of its common name. As John Gerard wrote in his classic *Herball, or Generall Historie of Plantes*, first published in 1597, 'It is called Devil's bit of the root (as it seemeth) that is bitten off. Old fantasticke charmers report that the Devil did bite it for envie because it is an herbe that hath so many good vertues and is so beneficent to mankind.' Although we wouldn't suggest digging it

up, its short, stubby tangle of roots do look as if they've been nipped off at their ends; apparently this is because their delicate tips tend to rot off in the soil.

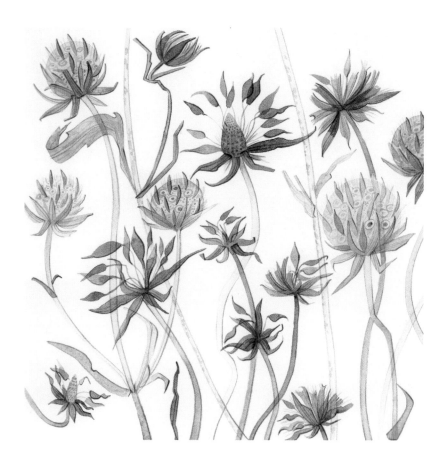

Devil's-Bit Scabious Study
Watercolour, 2015

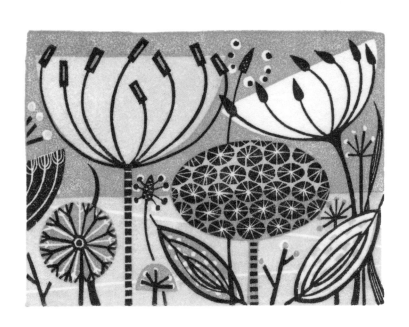

5

ALEXANDERS
Smyrnium olusatrum

In February, when everything is looking dead and brown on the coastal paths of Portland, the bright green leaves of alexanders are one of the first signs of spring. They look like celery, to which they're related, but their flowers, which start forming in March, are a startlingly vivid lime green. They're also rich in pollen, which attracts a host of flies, bees and beetles – and that, in its turn, attracts large numbers of chiffchaffs, the slender, pale green warblers that, in March and April, migrate to Britain from West Africa and the Mediterranean. Although you're only likely to glimpse them out of the corner of your eye, these shy little birds flit in and out of the deep rows of alexanders that line the cliff paths in the spring, fluttering briefly up and down as they catch

Clifftop III
Wood engraving, 2004

unwary flies. The scent of the flowers is said to have given them their botanical name: *smyrnium* is Greek for 'myrrh', although the fragrance has a sweet-sour character that's more like hawthorn blossom or meadowsweet. This spring I overheard a man on the clifftop path telling his son that their smell took him straight back to his childhood and the heady scent of fart powder.

How alexanders arrived in Britain is a bit of a mystery. They grow wild around the Mediterranean and along the Atlantic coasts of Spain and France, with oddly isolated populations in Denmark and north-western France, but they don't appear to be a native, although they're fairly widespread in southern Britain and Ireland. Their densest concentrations are around the coast and in the south-west, but they can also be found inland, especially on the sites of castles and monasteries. The further north you go, the less likely you are to see them; they're not known on Orkney or the Shetlands. It's widely assumed that they were introduced by the Romans as a food plant, which would help to explain why they're more commonly found in areas of ancient Roman, military and monastic occupation, although there's no hard evidence to back up that theory.

All parts of alexanders are edible, but I wouldn't describe them as a delicacy. In their unadulterated state, the stems and roots have a rather oily, bitter taste that resembles celery, only not as nice. The large seeds, which turn blackish-brown by July and August, are marginally more appealing, with a nutty flavour, although they also leave a bitter aftertaste. This rather begs the question: why didn't our ancestors simply grow celery instead? The reason, it seems, is that celery was domesticated in Britain much later than it was

in Italy or France. Wild celery (*Apium graveolens*), like alexanders, is pretty coarse in texture and earthy to the taste, and while it was used medicinally as a hangover remedy and aphrodisiac, it wasn't something you'd want to cook with. What Italian gardeners discovered, however, was that by mounding earth around late-sown celery plants over winter, you could blanch the stems, giving them a much more delicate taste and texture. The French military commander and gourmet Marshall Tallard is often credited with introducing this culinary innovation to Britain in the early eighteenth century, when he was under rather luxurious house arrest in Nottingham, although – as with most of these stories – there isn't any certain proof.

Despite these celery-related innovations, alexanders continued to be a popular pot-herb (that is, a plant grown for the cooking pot) right through to the nineteenth century. This may seem odd, but while their flavour might leave much to be desired, alexanders do have their advantages: they were one of the earliest edible greens to pop up in the winter, when there was little else available, and sailors used their leaves and seeds as an antidote to scurvy. Although they fell out of favour as celery became commercially cultivated, they've been rediscovered in a modest way thanks to the fashion for foraging, and they're now among those wild plants that many of us will have a go at cooking with – at least once.

Overleaf: *Clifftop, Weybourne* (detail)
Linocut, 2007

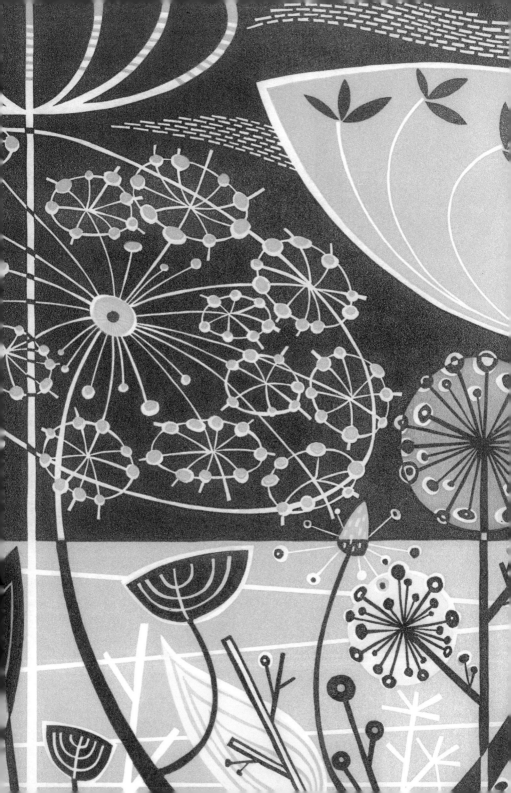

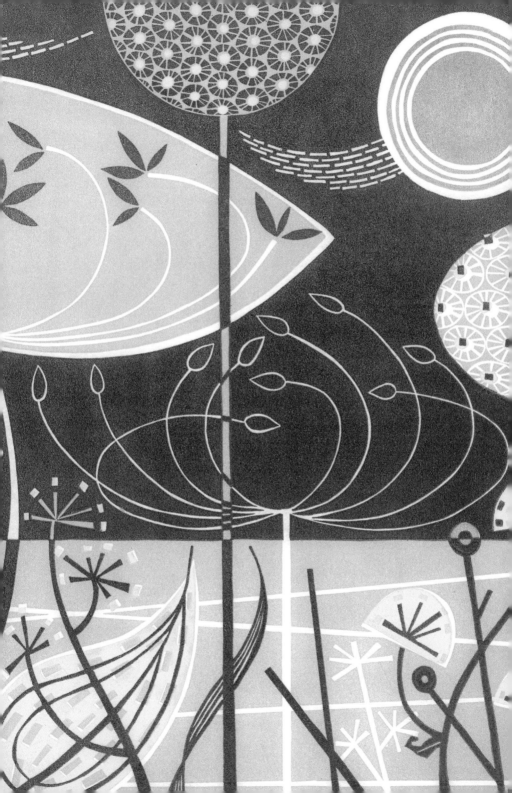

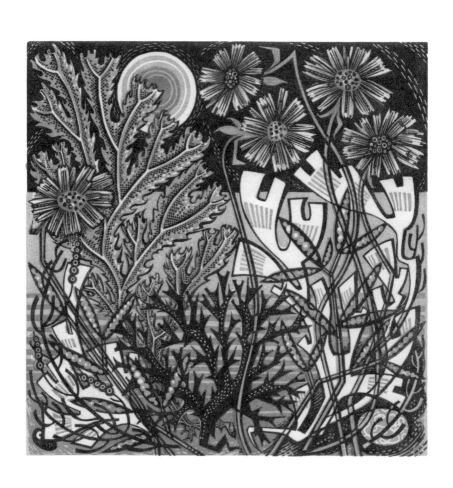

6

THRIFT
Armeria maritima

Each year from mid-April to early May, a greyish haze in the grass around the cliffs and along the shore heralds the flowering of the thrift. Within a week or two the grey turns mauve and pink, until some areas are completely carpeted with flowers. It's a spectacular sight. There's one particularly extensive area on the back of Chesil Beach that forms a kind of short, tussocky meadow divided by sinuous rills of pebbles, and each year we return to it again and again to wander between wave after wave of pink. It's our version of the Japanese cherry-flower festival, only looking down rather than up.

Also known as sea pinks and lady's pincushions, these tough little flowers have adapted, over millions of years, to conditions

Sea Pinks
Wood engraving, 2014

in which most other plants find it impossible to thrive. Growing close to the ground, with its narrow, grass-like leaves packed tightly together in low cushions, it shrugs off high winds. More importantly, thrift belongs to a relatively small group of plants called halophytes, which can cope with high concentrations of salt in the soil, as well as salt spray in the air. For most plants, salt is a killer, a fact that clears the ground along sea coasts for thrift and its compatriots, where they have few competitors. In evolutionary terms it's a remarkably useful adaptation, and its success can be measured by the fact that thrift has encircled the entire globe, in a zone running round the northern hemisphere, as well as parts of South America.

But salt tolerance is only one of thrift's tricks. Over the millennia it has split into numerous subspecies, each of which has adapted to live in other inhospitable environments, from rocky cliffs thousands of metres above sea level to sand dunes, salt marsh and areas that have been polluted with heavy metals, such as copper or lead, which it sequesters in its roots. This adaptability gives thrift the rare distinction of being a plant you're as likely to see near the summit of an Alp as in the bucket-and-spade surroundings of a bank-holiday beach.

There are, however, at least two things that thrift has yet to adapt to. One is rich soil. You might think that transplanting a plant from poor soil to rich soil would give it a shot in the arm, but cushy treatment (and especially over-watering) can actually cause thrift to suffer from diseases and rot. The other is feet. Despite its hardiness to weather and rocky ground, thrift is a slow-growing plant, and its hummocks of leaves are much less robust than they

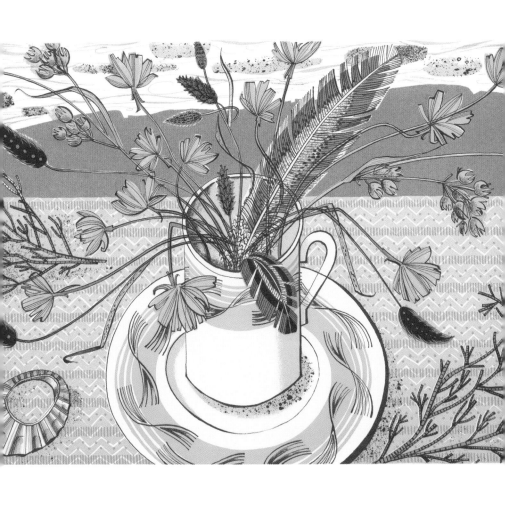

Knockando Thrift and Feathers
Screenprint, 2012

appear. Although the mounds look solid they are, in fact, hollow, with woody stems supporting the thousands of tiny leaves, and in areas with heavy footfall – such as coastal paths – they can quickly be damaged and worn away.

Yet of course what draws most people to thrift is its tufty little flowers, held up like balls of pink crêpe paper on straight green stems. They start as little red buttons, blood-blisters on stalks, opening out into a globe-shaped cluster of around twenty tiny individual flowers, each with five petals, stamens and styles. Although they're most commonly pale pink, their colour is variable, from pure white to lavender and mauve and even, occasionally, deep pinks that verge on red. Each plant has several flowerheads, which shake and shiver in the breeze and attract a wide range of pollinators, although they have only a faintly sweet fragrance, even en masse. After flowering, the seeds are held in a greyish, papery calyx, from which they are shaken by the wind.

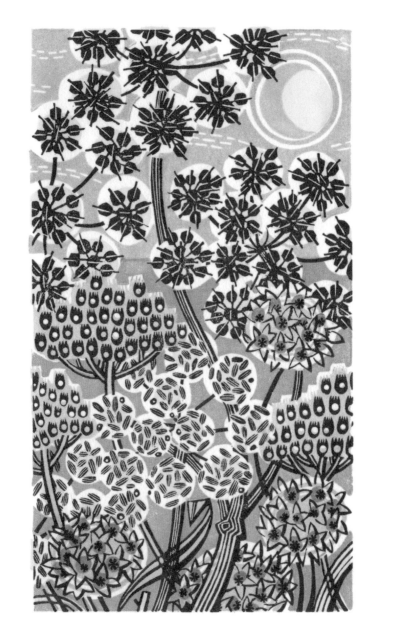

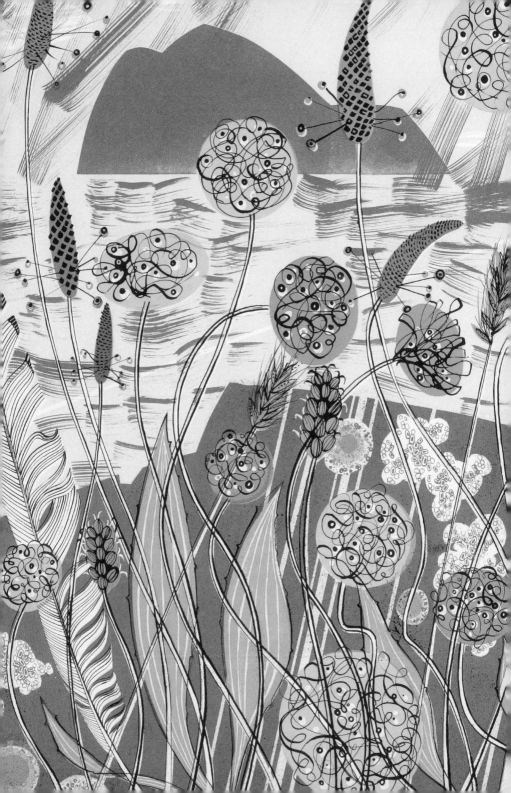

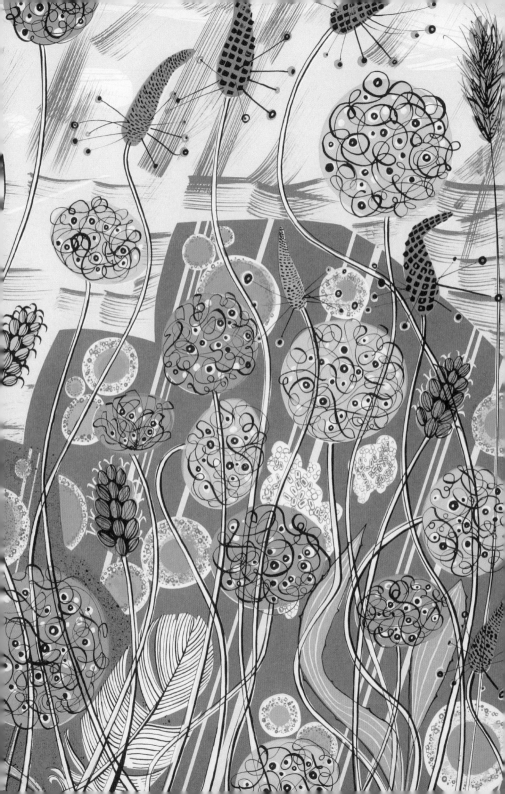

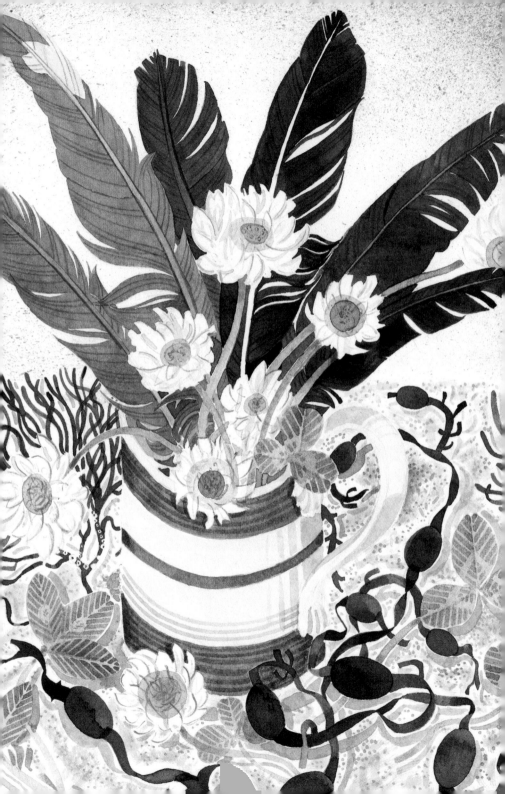

7

WHITE AND RED CLOVER
Trifolium repens & Trifolium pratense

Finding a four-leaf clover was always a magical moment as a child, although I've long since lost the ones I carefully pressed between sheets of blotting paper; I wonder where they are now. We say 'clover' as if it's a single plant, yet there are about thirty species of clover in Britain alone, including the intriguingly named subterranean clover, which inverts its seedheads after flowering and presses them down into the ground beneath.

The two commonest forms, though, are white and red clover, which are found all over the country, and indeed all over Europe, Asia and North America. Both have the distinctive three-lobed leaves that give the genus its Latin name, *Trifolium*, and their tiny individual flowers have the distinctive shape seen in many

Berneray Clover and Feathers
Watercolour, 2019

other members of the pea or legume family (from sweet peas to laburnum), with an upright petal framing a tubular, tongue-like centre. In white and red clovers these flowers are gathered in globe-shaped clusters.

White clover (*Trifolium repens*) is a short perennial plant that creeps through grassy fields and verges and can cover considerable areas – to the extent that it's sometimes planted to suppress weeds. It generally grows low to the ground, a habit that helps it avoid being heavily grazed, although its nectar-rich flowers have longish stalks, presumably to make them more accessible to bees. Its leaves are smooth, with paler crescent-shaped marks on each of its three leaflets. Red clover (*T. pratense*) is a larger plant altogether, and not quite so common, although it has been widely planted for forage and fodder. Its leaves can be distinguished from those of white clover by their pale, generally V-shaped markings and a fine covering of downy hairs.

All clovers, and indeed the majority of legumes, share a brilliant evolutionary mechanism that enables them to, in effect, create their own fertilizer. Modern farming is hugely reliant on artificial nitrogen fertilizers based on ammonia, which takes huge amounts of energy to produce (burning between three and five per cent of the world's natural-gas production each year) in a process that belches out vast amounts of greenhouse gases. Spreading artificial fertilizer on fields has enabled us to feed far more people than could otherwise survive, but only about half of the nitrogen is absorbed; the other half is wasted, leaching into streams, rivers and the sea and causing widespread ecological harm.

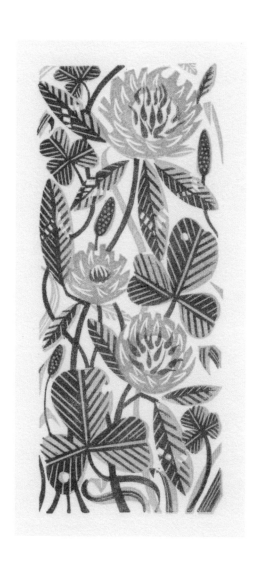

Clover
Wood engraving, 2014

Clover, by contrast, creates nitrogen silently, using virtually no energy, and without any waste. Admittedly, it's had millions of years to refine the process, while we've only being doing it since the early years of the twentieth century, but perhaps we should be planting more clover and producing less industrial ammonia. The way clover 'fixes' nitrogen is fascinating. Like many (indeed most) plants, it has evolved to have a symbiotic relationship with bacteria that live in the soil. And not just any bacteria; clover relies on a single species, *Rhizobium leguminosarum* biovar. *trifolii*. This clever little critter can fix nitrogen, but it doesn't have enough energy on its own to complete the process. For its part, clover is unable to fix nitrogen unaided, but what it can do is create sugars using photosynthesis, and it's these sugars that provide the energy the bacterium needs.

First, though, the clover has to attract *Rhizobium* to it, which it does by releasing flavonoids from its roots. Sniffing these, bacteria start clinging to the roots, which then curl around them and thicken to form protective nodules. Once safely inside, the bacteria lose their cell walls and form miniature nitrogen factories inside the host plant, fed by sugars from the leaves. Harvesting nitrogen in this way enables clover to thrive on poor soils where other plants would struggle, and also enhances photosynthesis, which in turn creates more sugars for the bacteria, as well as improving clover's ability to set more fertile seed. It's a win-win situation for both clover and bacteria, and probably the reason why clover is so widespread and so common.

Red Clover, Knockintorran (detail)
Watercolour, 2021

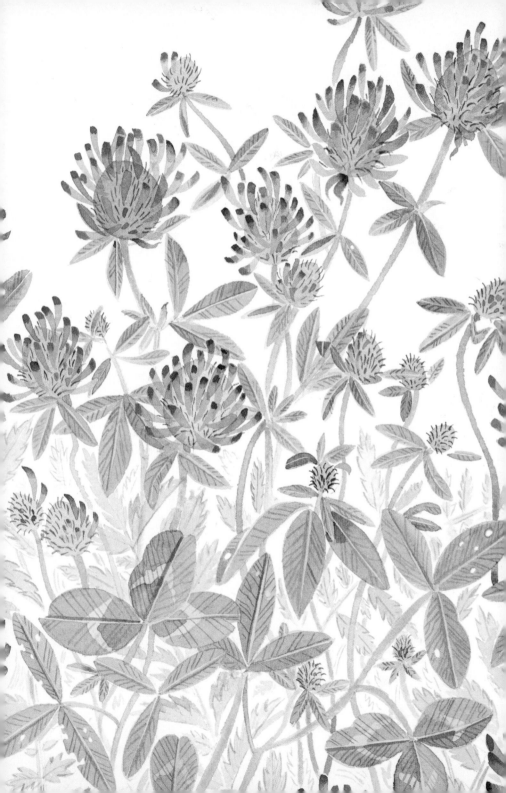

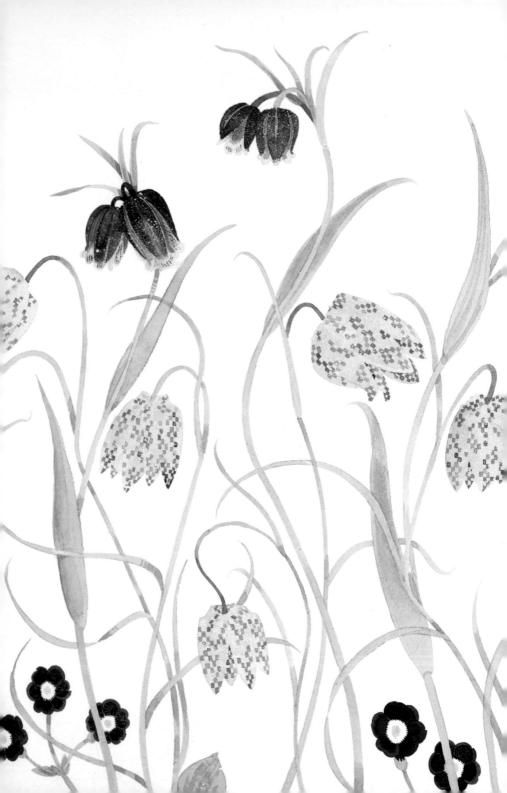

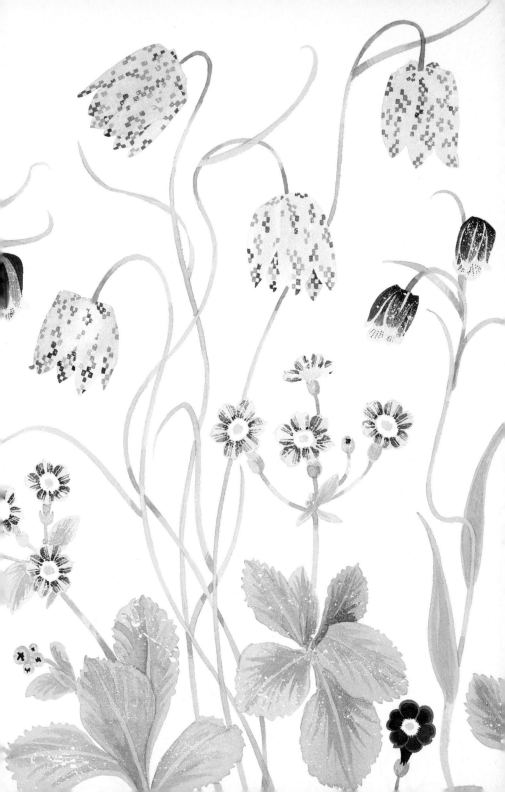

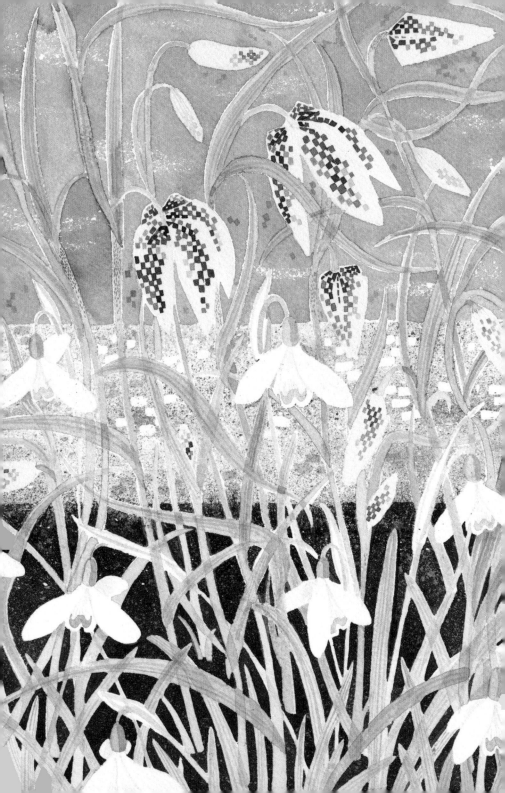

8

SNAKE'S-HEAD FRITILLARY
Fritillaria meleagris

It's hard to think of a more beautiful British wild flower than the snake's-head fritillary, with its nodding, plum-coloured flowers decorated with a strikingly regular chequerboard grid. Sites such as the Magdalen College Water Meadow in Oxford and the Fox Fritillary Meadow in Suffolk have, unsurprisingly, become places of pilgrimage, where each April you can see thousands flowering at once, with a scattering of ivory-white variants among them.

Although snake's-head fritillaries are one of the most popular additions to planted wild-flower meadows, it's extremely rare to find them growing wild, and there are only about twenty such sites remaining in Britain. Yet they were once a relatively common flower of damp hay meadows in central and southern England.

Fritillaries and Snowdrops
Watercolour, 2019

Previous: *Fritillaries and Auriculas*
Watercolour, 2022

Their decline and disappearance echoes those of many other wild flowers, but has its own specific elements as well. Doubtless their flowers were always plucked as well as admired, but it was picking on a commercial scale in the nineteenth century that first seems to have knocked their numbers back, as train-loads of wild flowers were sent to market in London and Birmingham. The twentieth century only accelerated their decline, as ancient pasturelands and water meadows were ploughed up and drained for more intensive farming, destroying the fritillaries' habitat and their surprisingly large white bulbs.

These spring-flowering bulbs are found across Europe, from France and Italy to the former Yugoslavia, and as far east as Siberia, but it seems likely that they were introduced into Britain, rather than being truly native – although this is far from a settled debate. They were first described as garden plants in John Gerard's *Herball*, in 1597, but it wasn't until 1736 that they were first recorded in the wild (at Harefield, now on the edge of London), which suggests they had escaped from gardens during the intervening 150 years. One possibility is that their spread was inadvertently abetted, from the early seventeenth century, by the development of water meadows, which created large tracts of damp grassland in southern England to provide early grazing for sheep – and perfect conditions for fritillaries.

Although they sound natural enough, water meadows were actually artificial, and used an elaborate system of ditches, hatches and sluices, operated by an evocatively named 'drowner', to flood the pasture over winter with a shallow layer of gently flowing water. This prevented the ground from freezing in cold weather, spread

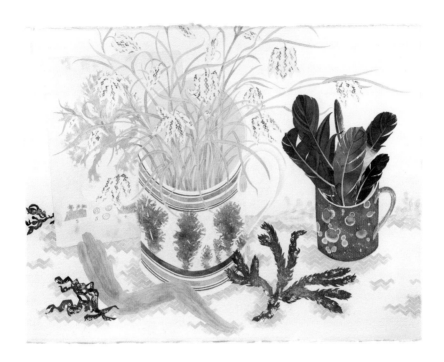

nutrients and encouraged a lush growth of new grass early in the year, thus supporting larger flocks than would otherwise have been possible. Water meadows are first mentioned in the early 1600s, and through the eighteenth and nineteenth centuries they spread along chalk streams in many areas of southern England, before being largely abandoned around the time of the Second World War. They would have provided a perfect habitat for the snake's-head fritillary, as well as for many other damp-loving species, such as devil's-bit scabious (page 29) and lady's smock.

The common name might sound a bit puzzling, since the mature flowers look nothing like snakes' heads, although they do have forked stamens like an adder's tongue. Look at them in bud, however, and the analogy makes more sense; with their pointed

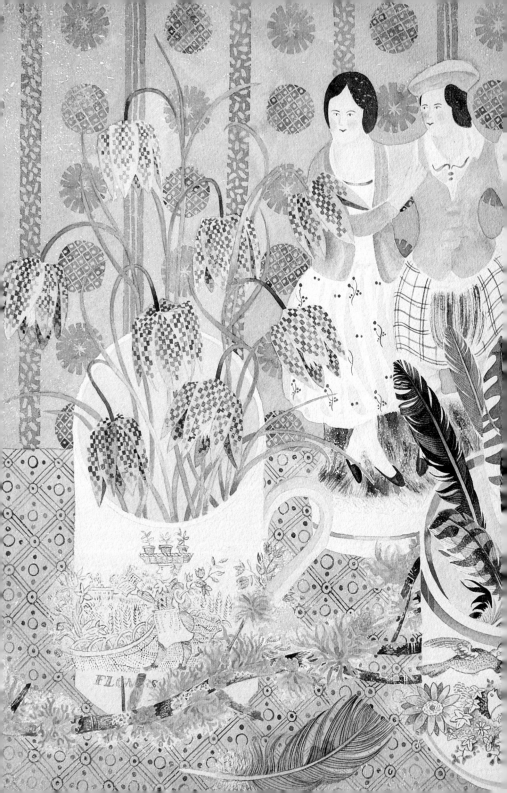

tips the buds do look rather serpentine. The botanical name, *Fritillaria meleagris*, takes a little more explaining. Like many other botanical names, it was coined by the great botanist Carl Linnaeus for his enormously influential treatise on the plant world, *Species Plantarum*, first published in 1753. Both parts of its name – genus name and species – refer to the chequerboard pattern on the flower. *Fritillaria* derives from *fritillus*, the Latin word for 'dice box' and thus, by association, a chequerboard. *Meleagris*, meanwhile, was the ancient Greek word for 'guineafowl', a bird whose mottled plumage is reminiscent of fritillary petals.

Arguably the most spectacular place to see fritillaries today is in the Water Meadow at Magdalen College, Oxford, where they flower in their hundreds of thousands. With its backdrop of dreaming spires and the placid waters of the River Cherwell flowing by, it's a timeless scene, although the earliest mention of fritillaries there was as late as 1785. Given that the famous Oxford Botanic Garden was founded literally over the road in 1621, you'd have thought someone would have noticed them if they were already growing there then, so it seems more likely that they were introduced from elsewhere. Intriguingly, Magdalen College owned land in the village of Ducklington, just ten or so miles to the west, which also has a famous fritillary meadow, so one theory is that Magdalen's flowers were originally transplanted from there.

Speyside Fritillaries and Feathers (detail)
Watercolour, 2023

Previous: *Fritillaries and Feathers*
Watercolour, 2020

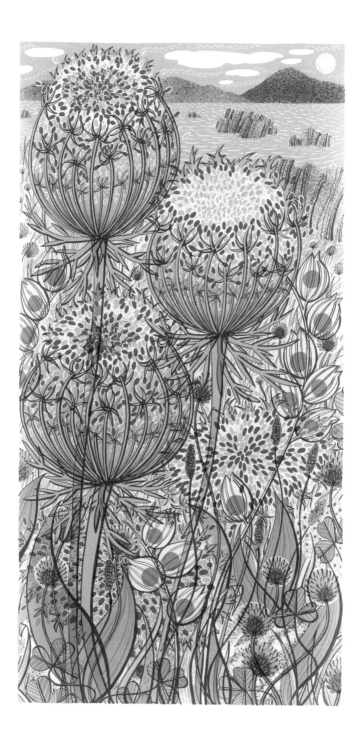

9

WILD CARROT
Daucus carota

Although you wouldn't want to eat their bitter, stringy roots, wild carrots are closely related to their cultivated cousins, *Daucus carota* subsp. *sativus*, as the carroty scent of their crushed leaves suggests. They grow wild around the coast, as well as in fields and on waste ground inland, especially in areas of chalk and limestone. Their off-white or pale pink flat-topped flowerheads appear in early summer, and like cow parsley and fennel, they're composed of hundreds of tiny individual flowers, which attract a huge range of pollinators. They can be fairly easy to confuse with other members of their family, the Apiaceae, which includes edibles as well as highly poisonous plants like hemlock, but they're the only species to smell of carrots, so if you're not sure, try crushing their ferny leaves.

Wild Shore
Screenprint, 2018

The flowers of wild carrot have two other distinguishing features. As they dry out and go to seed, the flowerheads close up into a loose, clustered ball, which has often been compared to a bird's nest. More puzzlingly, right in the centre of many of the flowerheads is what looks like a black spot. Look closer, though, and you'll see that it's actually a single tiny flower – just like all the others around it in form, but dark red-purple to black in colour. It's a striking feature, yet, despite more than a century of scientific enquiry, we still have no idea why it's there. There have been various theories: that it acts as a come-hither signal to passing insects, or misleads the parasitic gall midge, *Kiefferia pericarpiicola*, into thinking that other midges have parasitized the flower ahead of them. Yet none of the current hypotheses stands up to close scrutiny, and it seems that, as Charles Darwin suggested back in 1888, the dark floret is a bit like our appendix: an oddity whose original function has long been lost.

Blue Meadow
Linocut, 2004

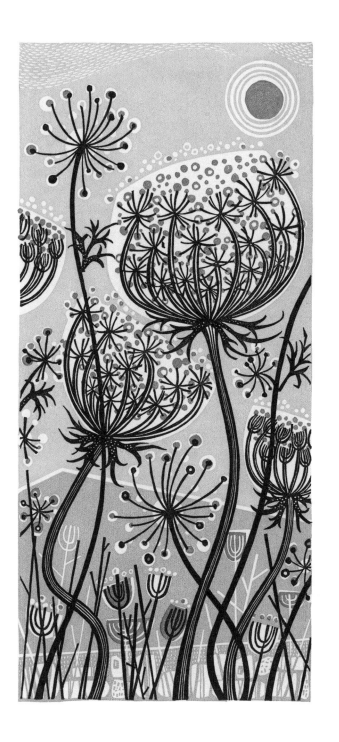

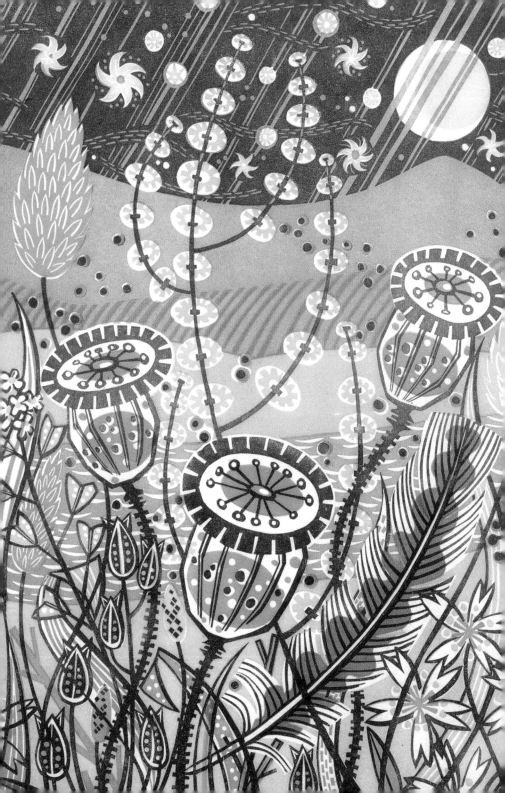

10

CORN POPPY
Papaver rhoeas

Poppies are so much part of Britain's national mythology that it can be a surprise to learn they're no longer the common weeds that flowered in their millions in the years around the First World War. Until the 1950s they stained fields red, but since then their numbers have imploded, thanks largely to modern herbicides.

Like dogs, they're closely linked with people, and have followed in their wake wherever they tilled their fields. Poppies need disturbed ground to thrive, and their annual life cycle mirrors that of annual crops, such as wheat and oats. Each plant can produce as many as 400 self-fertile flowers in a season, and spread more than 60,000 seeds, which can survive for a decade or more in the soil. As with most wild species, they're far more variable

Season Songs (detail)
Linocut, 2019

than garden plants, whose flowers we value (and name) for their consistency.

This genetic diversity has enabled poppies to survive and prosper for thousands of years, and it will also, eventually, enable them to develop resistance to our herbicides. Their flower colours are variable, too, which is why, in the 1880s, the Reverend William Wilks was able to raise his famous multicoloured poppies in the (then) village of Shirley, just east of Croydon. Intriguingly, it seems the corn poppies that became a symbol of the First World War were slightly different from the poppies we see today, in that they were pure red; a century on, the commonest types of corn poppy have red petals with a black blotch at the base.

You might think they'd make a perfect plant for a wild-flower meadow, but despite their astonishing fecundity, poppies are hopeless in grassy swards. No matter how much seed you scatter about, they need open soil to grow, and unless you're willing to plough your entire garden each spring, they're unlikely to flourish as they would in the wild.

Autumn Garden, Norfolk
Screenprint, 2013

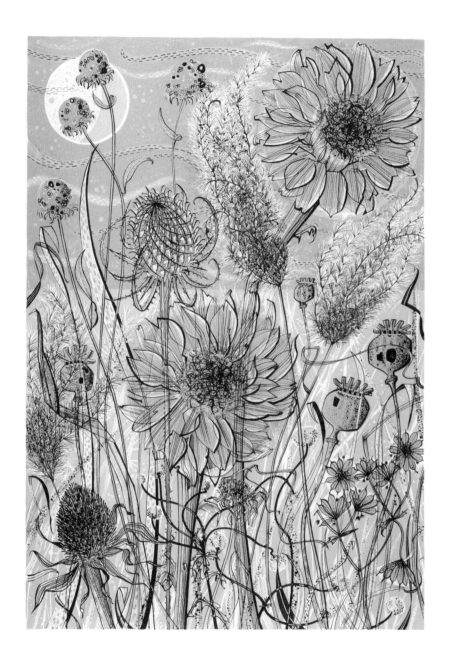

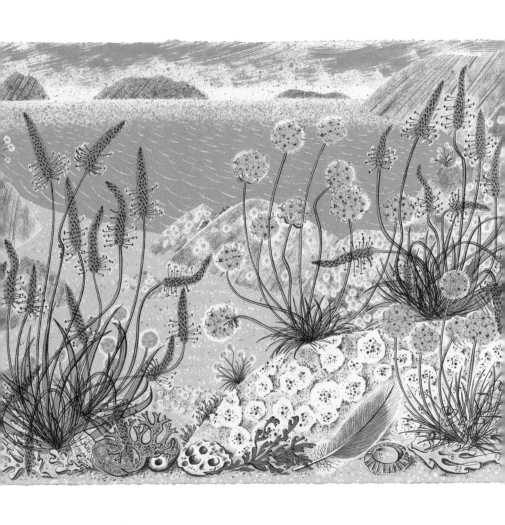

11

PLANTAINS
Plantago spp.

When I was a child, I'd follow my father on long walks down the lanes that led out from our Yorkshire village, and it was my dad who showed me how to make a blade of grass screech and a bladder campion pop. Until I began writing this I'd forgotten how he'd also shown me how to shoot plantain seedheads by tying a slip knot in their flexible stems. These were most probably ribwort plantains (*Plantago lanceolata*), one of the five members of the *Plantago* genus that grow in the British Isles, and the commonest species of them all.

All five British plantains share some features, but they are fairly easy to distinguish from one another. Along with dandelions and daisies, they're among the most widespread plants in the country,

Summer Shore
Screenprint, 2016

and that's partly thanks to the way they grow. All have a flat rosette of leaves and a deep tap root, as anyone who's dug them out of their allotment will know. Being flat to the ground, their leaves are resistant to mowing, not to mention tough as old boots; they can take any amount of trampling, which is why you'll often see them surviving on well-trodden paths when even the grass has worn away.

Ribwort plantain has long, ribbed leaves with pointed ends – lance-shaped or lanceolate in botanical terminology, which is where its Latin name comes from. Its tiny brown flowers are clustered at the top of a long stalk, in a stubby flowerhead that looks a bit like a cigarette end, and have bristly off-white stamens, which is what (if anything) catches one's eye. The 'rib' part of its common name derives, of course, from the ribbing in the leaves, but the 'wort' suffix is a clue to their history as a folk medicine. The leaves contain chemicals that make them bitter to the taste, but which also have a calming effect on the skin; in fact, they're considered to be a more effective antidote to nettle stings than dock leaves are. Although you wouldn't want to eat their leaves, their flower buds apparently taste a bit like mushrooms. As plants they're remarkably undemanding, and grow happily on roadsides, in lawns and meadows, wasteland and even sand dunes, so it's no wonder they're seen just about everywhere.

Their larger cousin, greater plantain (*P. major*), has much wider, almost cabbagey leaves, which rise on longer stems. They also have similar astringent effects and taste just as bitter, which makes one of its many other common names, 'waybread', seem rather puzzling, until you learn that 'bread' is an ancient variant of

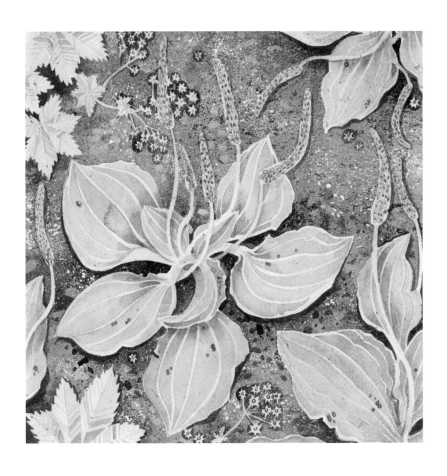

Plantain and Lady's Mantle
Watercolour, 2021

Page 75: *Sollas Sands* (detail)
Linocut, 2015

'broad', referring to the breadth of its leaves. So 'waybread' is simply the broad-leaved plantain (another of its common names) that grows by the road, or way. Greater plantain can also be identified by its flowers, which are borne up almost the full length of their stems, giving them the look of a pipe-cleaner or the tail of a rat; rat's tail is yet another of its popular names. They have a long flowering period, and set thousands of tiny seeds, which are easily picked up by birds, as well as the feet of passing walkers and grazing cattle. When English settlers introduced them to North America, they spread so quickly that they became known to Native Americans as 'Englishman's foot'.

Although it isn't as common as greater or ribwort plantain, hoary plantain (*P. media*) is often to be found on chalk and limestone grassland in central and southern England. It's perhaps the prettiest member of its genus; although its flowerheads are fairly short, the flowers themselves are showier than those of the other plantains, with a puff of rather untidy pale pink stamens on long purplish stalks. Selected forms with stronger colours have sometimes been planted in gardens, where they look a bit like miniature red-hot pokers. They're also mildly fragrant, which is another thing that sets them apart from the other British plantains, and less common, although – for some mysterious reason – a good place to look for them is in churchyards. Their broad leaves look similar, at first glance, to those of greater plantain, but hoary plantain leaves are covered with short white hairs – which is where the common name comes from.

The final two British plantains share a taste for the sea, and have both adapted to the salty conditions found along the coast,

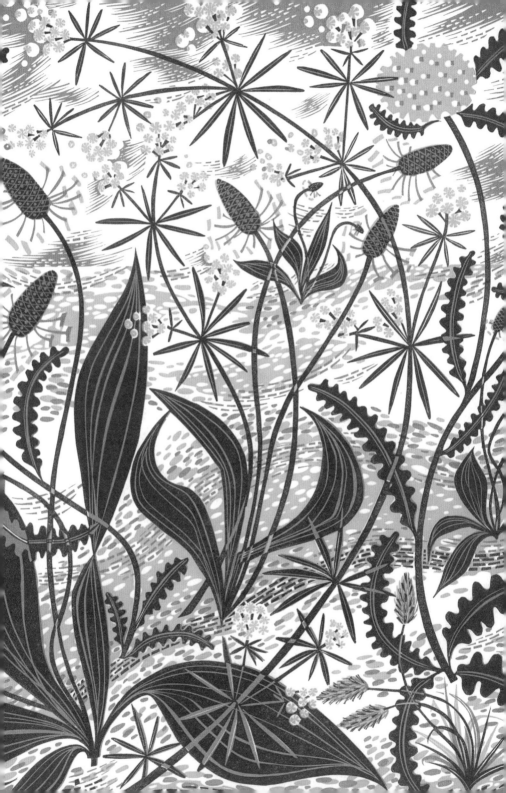

although they look quite different from each other and thrive in slightly different terrain. Like thrift, they're halophytes – literally 'salt-lovers', although the Greek term is actually a bit misleading. It would be more accurate to call them 'salt tolerators', which is to say they have evolved strategies to deal with salty soils and winds that would kill or shrivel lesser plants.

Sea plantain (*P. maritima*) is quite distinct from other British plantains in that its leaves are narrow, fleshy and usually upright, rather than forming a flat rosette on the ground. Its tiny flowers are, like those of the other plantains, held on thin bottlebrush-like spikes, with flattish stems that are crescent-shaped in cross section. It grows all round the coast, on sea walls, in salt marshes and on rocky shores, and although like most plantains it seems to like growing as isolated plants, it can sometimes be found en masse, especially on the drier margins of salt marshes.

Buck's-horn plantain (*P. coronopus*) is, like sea plantain, a salt-tolerant creature, but its distribution is weirdly different. Although both species can be found right round the coasts of Britain, sea plantain's real stronghold is in north-western Scotland, where it can be seen well inland. Buck's-horn plantain, by contrast, is widely spread in south-eastern England, but not as common as sea plantain in Scotland. This seems to have something to do with their relative hardiness. Sea plantain thrives as far north as the Arctic Circle, while buck's-horn plantain only manages to make it to southern Scandinavia, so it is getting towards the upper limit of its range in northern Scotland. Even more intriguingly, over the last half-century both species have spread much further inland, which seems puzzling until you look closely at the records

of where they've been found. It turns out that they have been following main roads and motorways, which began to be de-iced in the 1960s, using salt that killed less salt-tolerant plants but had much less of an effect on sea and buck's-horn plantains.

Buck's-horn plantain is the most variable of its genus in size, and also has the most attractive (and palatable) leaves. Narrow and slightly fleshy, they grow in the usual flat rosette, but are often deeply cut, giving them the look of a lace doily. In Italy buck's-horn plantain goes by the romantic name of *erba stella*, or star grass, and has long been cultivated as a salad ingredient; the leaves have a crisp, nutty flavour reminiscent of parsley and spinach, with a hint of salt and a pleasantly bitter aftertaste. Easy to grow from seed (look for the cultivar 'Minutina'), it is very cold-hardy and makes an excellent winter crop; the leaves are said to taste best after a frost.

Sea Plantain
Wood engraving, 2016

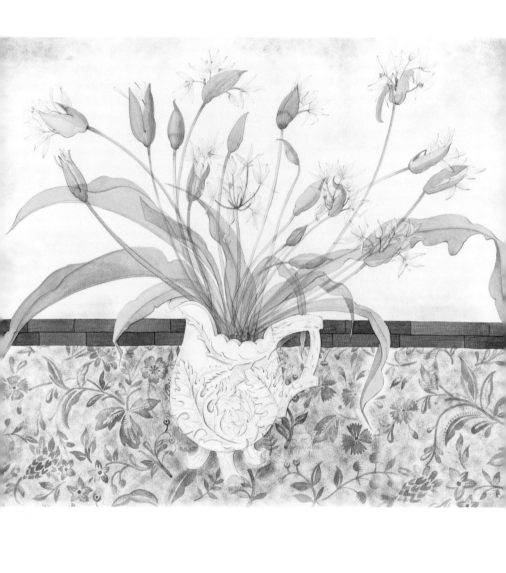

12

RAMSONS
Allium ursinum

The penetrating smell of onions fills the woods of Dorset in late May, as the ramsons come into bloom. Their pretty white flowers, little starbursts on short stems, carpet the ground, especially on steep slopes under one-time hazel coppices. Their oniony scent may not be very appealing, but it reveals that they are related to our garden onions, as well as all those decorative pink and purple alliums that are such a staple of modern bedding schemes.

I've always found their common name, ramsons, oddly hard to pronounce, perhaps because it's so similar to 'ransom', and it's odd in another way as well, always being plural – when did you last hear anyone talk about a ramson? In fact, 'ramson' is already a plural, since it derives from the Anglo-Saxon word for wild

Ramsons and Thistle Pot
Watercolour, 2015

garlic, *hramsa*, and when Anglo-Saxons wanted to make a plural, they didn't add 's', as we do; instead, they added 'en', an ending that survives in such words as 'children' and 'oxen'. Thus *hramsa* became *hramsen*, evolving via 'ramsen' to 'ramson', which means that 'ramsons' is actually a double plural.

Ramsons are found all over Britain, and they're an excellent indicator of ancient woodland, where their smooth, spearhead-shaped leaves can carpet entire hillsides. They're often found with bluebells, which grow in similar abundance, but they almost always occupy different areas and rarely if ever seem to mix, for no reason that I've been able to discover. They thrive in similar conditions, in deciduous woodland with light shade, and prefer chalky soils (which is why they're so common in Dorset). Ramsons come into leaf a little earlier than bluebells, which perhaps gives them an advantage early in spring, although bluebells seem to be happy in drier conditions than ramsons will tolerate; I've even seen them growing in sandy soil in open ground, so maybe they complement rather than compete with each other.

In recent years ramsons have become one of the most popular plants for foraging, and for good reason: wild garlic pesto is delicious, as is chicken roasted in ramson leaves, although its flavour is milder than culinary garlic (*Allium sativum*). The leaves are best before the plants come into bloom, and the bulbs should be left alone – not only because they ensure the survival of the colony, but also because they're slimy and almost flavourless.

Foragers often confuse ramsons with another, non-native allium that shares their garlicky flavour: *A. triquetrum*, popularly known

as the three-cornered leek after its three-sided flower stem. This garden escapee from south-western Europe has spread from Cornwall across southern England, although it's easy to distinguish from ramsons and favours quite different habitats. *A. triquetrum* has long, narrow, slightly hairy leaves and drooping rather than upright flowers, and is most often found in gardens and along roads, where it can be extremely invasive and difficult to eradicate, so plant it (if you must) with care.

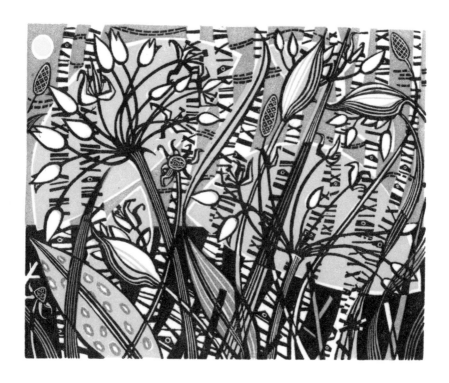

Ramsons
Wood engraving, 2009

Overleaf: *Ramsons and Campion*
Screenprint, 2013

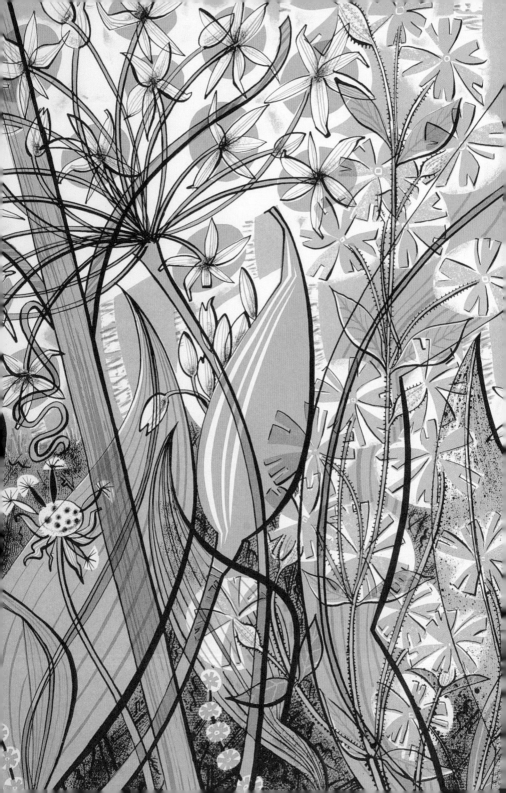

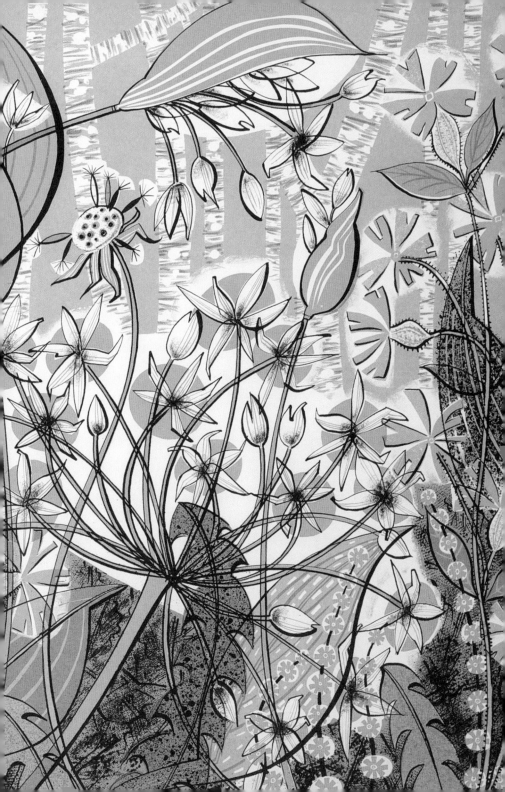

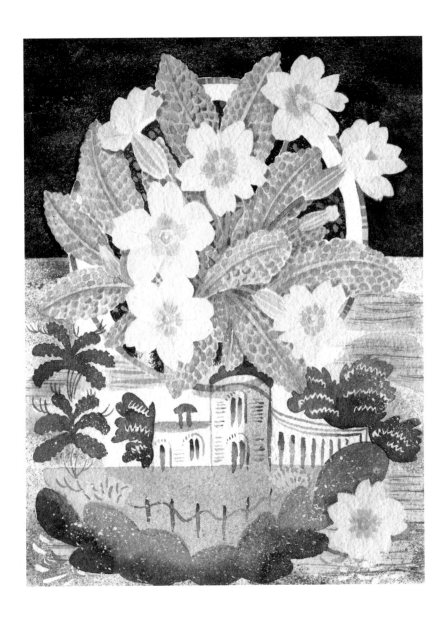

13

PRIMROSE
Primula vulgaris

In the right conditions, primroses are among the first wild flowers to come into bloom, sometimes appearing before Christmas in southern England, and continuing to flower right through till May. They're native to Europe, as well as Morocco and Algeria, although surprisingly rare in Poland and Sweden, where you're far more likely to see cowslips than primroses.

Although they will grow in a wide range of habitats, primroses are happiest in damp, lightly shaded spots, especially steep banks out of full sun. They have shallow roots and suffer in dry weather, which might explain reports that they are becoming less common in south-eastern England, perhaps thanks to climate change. Yet their distribution has always been puzzling. Primroses are

Primrose with Lustreware Cup
Watercolour, 2023

commonest in the wetter western parts of Britain, but they also grow profusely in Suffolk, one of the driest parts of England, so their numbers are not simply related to dry versus wet.

Primrose yellow is well known enough to have given its name to a colour, and even the leaves of the plant often have a fresh, yellowish tinge, but occasional plants have cream or even pink flowers. These are frequently found in churchyards, but whether the pink flowers are natural mutations or the result of mixing with garden primulas is not certain. What is well known is that gardeners have crossed them with other species of primula for centuries, creating the multicoloured polyanthus flowers that brighten up many a municipal bedding scheme.

Look closely at the centre of primrose flowers and you'll discover another oddity. The blooms of one plant may have a single, slightly projecting style (the tube that conducts pollen down to the ovary), while in other plants it's the five stamens (bearing pollen) that project, with the style tucked further inside. Successful fertilization happens only between the two different types of flower, promoting genetic diversity.

Island Primrose (detail)
Screenprint, 2022

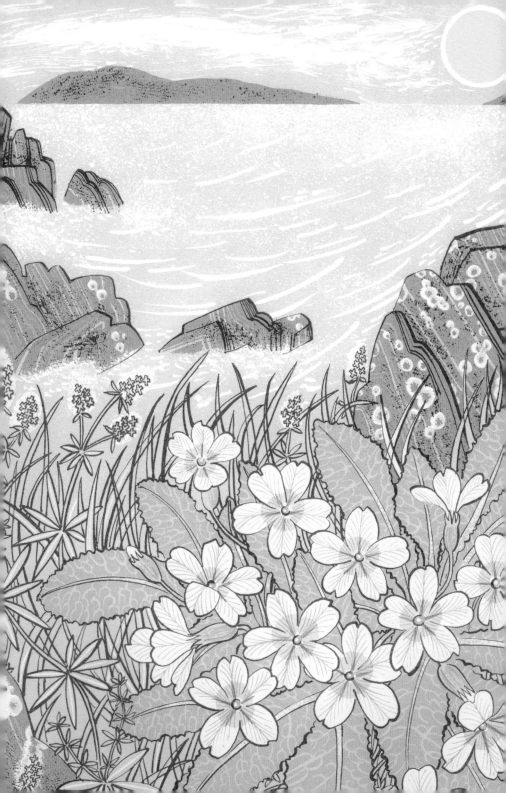

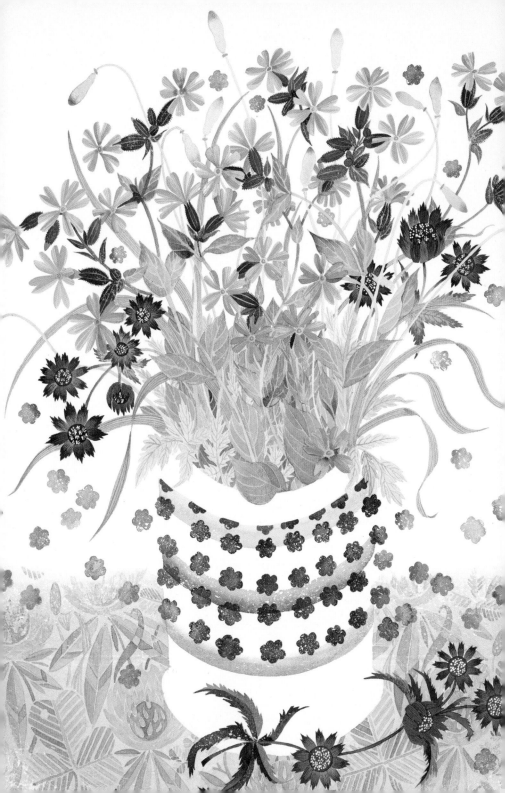

14

CAMPIONS
Silene dioica & Silene latifolia

Late spring, and the woods are sweet with bluebells. They clothe the ground like fallen sky, and where a lane leads out of the trees they scatter along the verge, mixed with wood anemones, stitchwort and golden celandines. The intensity of their colours dazzles the eye, but one flower positively fluoresces in the sun, and that's the red campion, *Silene dioica*. Its common name is puzzling, since it isn't commonly red at all but rather the brightest, most eye-popping shade of Schiaparelli pink (although it does sometimes come in other shades, from magenta to pale salmon). I think it's one of the most beautiful British natives, and luckily it's anything but rare, although it prefers woodland and light shade to open ground, and like all wild flowers has suffered sharp declines in herbicide-happy areas of industrial-scale arable agriculture.

Campion, Astrantia and Clover (detail)
Watercolour, 2022

Red campions begin to flower in spring, but their flowers continue to appear, if generally in less profusion, through the remainder of the year, held above one another on long stalks that can reach a metre or more in height. Their Latin genus name, *Silene*, was invented by the great Swedish botanist Carl Linnaeus, inspired by the minor Greek forest god Silenus, who seems to have spent most of his time drunk. Linnaeus made the connection not because campions have anything to do with alcohol, but for a far more esoteric reason: because Silenus was often portrayed covered in spittle or froth, presumably after foaming at the mouth. Campion stigmas also produce a froth that apparently helps to capture pollen from visiting insects.

The second part of its name, *dioica*, meaning 'of two houses', refers to the fact that campions are dioecious, meaning that they have male and female flowers on separate plants. Although at first glance the male and female flowers look pretty much identical, with five more-or-less deeply divided petals, they're easy to tell apart. Look closely at each bloom and you'll see, in the centre, either five yellow hammer-headed stamens pointing out, which means it's male, or five curly white stigmas, in which case it's a female flower.

Red campions' less showy cousin, the white campion (*S. latifolia*) was long considered to be native too, but more recently it's been reclassified as an archeophyte – that is, a plant that was introduced before 1500. Whenever it arrived (and some authorities suggest it was as early as the Neolithic period), it has since spread across Britain, although it's rather less common in the west than elsewhere. Apart from the colour of the flowers the two species

are remarkably similar in appearance, and easily interbreed, but they do have other distinguishing features. Unlike its pink relative, white campion grows happily on disturbed waste ground and in full sun, and its five petals are so deeply divided that they often look like ten. The flowers also open later in the day and have a faint fragrance of cloves, being pollinated by the lychnis moth (*Hadena bicruris*), which is attracted at night by their scent. Red campion, by contrast, is scentless and pollinated by day-flying bees and hoverflies.

Campions may be commonplace, but dioecious plants like them are surprisingly rare. Only about five per cent of plants have separate male and female flowers, and this curiosity, along

with their ready availability, has long made campions a subject of scientific study. Perhaps the most striking (and oddest) aspect of their biology is that, like animals, red campions can suffer from what looks very like venereal disease. Anther smut is a fungal parasite that affects their flowers, turning the centres black and staining the petals with sooty marks.

Charles Darwin was fascinated by the disease, and corresponded about it with the pioneering Manchester botanist and suffragist Lydia Becker, who was the first to describe the extraordinary effect it has on infected flowers. The parasite, which belongs to the genus *Microbotryum*, forces male flowers to produce black fungal spores instead of yellow pollen, but it does something even weirder to the female flowers: it changes their sex, suppressing the female stigmas and replacing them with infertile stamen-like structures called staminodes, which also churn out fungal spores. These spores are then inadvertently picked up by visiting pollinators, which fly on to infect other red campions. Nature's inventiveness is endless, if not always appealing.

Previous: *Seedheads, Feathers and Bracken* (detail), watercolour, 2015

Opposite: *Campion and Columbine Seedheads with Spey Feathers*, watercolour, 2015

92

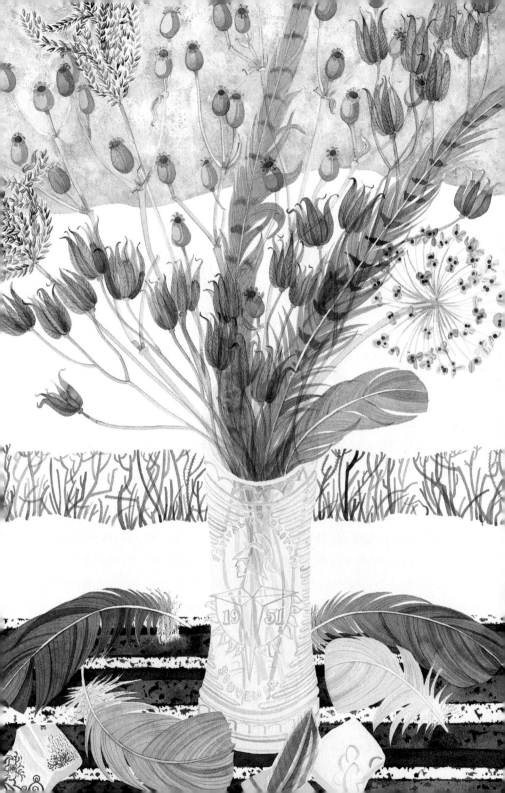

15

IVY
Hedera helix

There's something a bit creepy about ivy. It lurks in dark places. It straggles and it strangles. It can grow through walls. It smells dusty and strange and can give you a rash. It's not a parasite, yet it's definitely a user: it creeps along the ground, smothering everything in its path, then takes advantage of whatever it meets – trees, walls, fences, even gravestones – to haul itself up into the light. It's a shape-shifter, as well, with two completely different types of leaf and stem: one type for creeping and climbing, and another for flowering. It is, in short, one weird plant.

Yet it also has its merits. Its glossy, dark green leaves come in a multitude of shapes, and take on a brilliant metallic sheen in winter sunshine. Its vigorous, smothering aspect makes it useful

Ivy Winter
Wood engraving, 2011

for ground-cover and to hide unsightly masonry and fencing, and it will grow in the dustiest, least nutritious soils. It comes into bloom just as most other flowering plants have died down, and in October and November its mace-like lime-green flowerheads attract swarms of flies and bees. And its hard black berries help many birds to get through the winter.

There has been much debate over whether ivy damages walls and trees. Ardent hederaphobes contend that it winkles its way into crevices and mashes up mortar, and that its verdant growth strangles trees and makes them dangerously top-heavy in high winds. Hederaphiles say this is rubbish, and that ivy does little or no harm, either to trees or to buildings. Interestingly, worrying about ivy seems to be a rather modern phenomenon. For early antiquarians and lovers of the past, such as the poets Keats and Wordsworth, ivy added an extra layer of romance to ancient ruins; it was a deliciously melancholy reminder that all things decay and crumble.

Early photographs of historic monuments show many of them shrouded in ivy, and it was evidently considered to be part of their appeal. Although the occasional dissenting voice was raised, it wasn't until the early twentieth century that the tide against ivy really turned. In many ways it echoed the reaction against nineteenth-century fussiness and clutter that took place in design and architecture, in favour of the spartan, hygienic tenets of Modernism. When it came to architecture, the high priest of this new cult was Le Corbusier, but the reaction against ivy was led by a rather less world-famous figure. Sir Charles Reed Peers may not be a household name, but his influence, like Le Corbusier's,

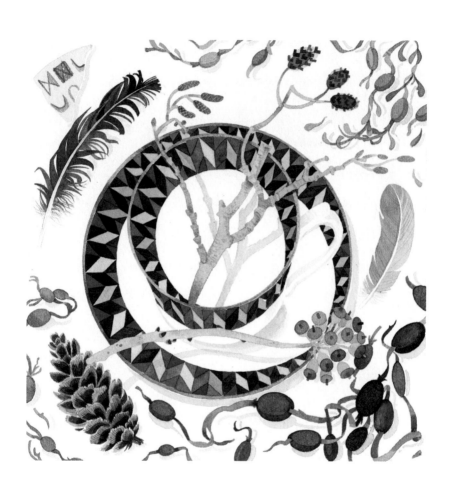

Tea Cup, Catkins, Ivy and Cone
Watercolour, 2020

continues to be felt to this day. Born in 1868, he trained as an architect, but also edited the *Archaeological Journal* from 1900 to 1903, and in 1910 he was appointed Inspector of Ancient Monuments at the Office of Works.

This ancient institution was originally founded in 1378 to look after royal castles and palaces, but by the time Peers joined its remit had broadened to include ancient buildings of all kinds. He became Chief Inspector in 1913, and over the thirty years of his tenure, he oversaw an immense programme of rescue, repair and renovation, as well as acquisition, which transformed many of the most famous sites in England, from Stonehenge to Hadrian's Wall. Peers's work was widely admired, and he saved many buildings that might otherwise have been lost, but one aspect of his approach has since come in for widespread criticism. This was his aversion to 'accretions', including ivy, which was ruthlessly stripped from the walls of any historic buildings that came into his care.

At Rievaulx Abbey in Yorkshire, for example, hundreds of workers were employed to clear vegetation and remove post-medieval buildings, including an astonishing 90,000 tonnes of soil and masonry. Sites were fenced off and carefully levelled, with bare stone walls surrounded by acres of smoothly mown grass. Although Peers's aesthetic was developed during the 1920s, its influence remains strong, and can still be seen today at many of the monuments managed by the Office of Works' successor, English Heritage, as well as by the National Trust.

Peers's antipathy to ivy may have spread far and wide, but in more recent years the plant's dangers have started to be reassessed, not least in academic reports commissioned by English Heritage and the Royal Horticultural Society. Their findings are more nuanced and less forthright than those of their predecessors, and suggest that ivy causes little or no damage to walls that are in good repair; in fact, it can actually shield masonry from the worst effects of moisture and temperature, as well as sheltering many species of insect and bird. The Woodland Trust has embraced ivy too, and avers that the plant does no harm to trees.

On the other hand, there's no doubt that ivy can root into loose masonry and lift roof slates if left entirely to its own devices, so a certain amount of vigilance and pruning is to be recommended. And beware, if you do decide to try and remove ivy from a wall entirely, for the most popular method of checking its growth proves to be counterproductive. Most guides still recommend cutting it off at its roots at ground level, then waiting for the growth above to die back. In practice, though, this stimulates the remaining ivy to produce new roots higher up, which can quickly work their way into any loose mortar and do more damage than if it had been left alone. The safest – and usually easiest – method of removing ivy is to peel it carefully back from the top, although of course that often means using ladders. In most cases it's better for the birds, the bees and whatever the ivy is climbing up to leave well alone.

Overleaf: *Lustreware and Ivy, Glenarder*
Watercolour, 2020

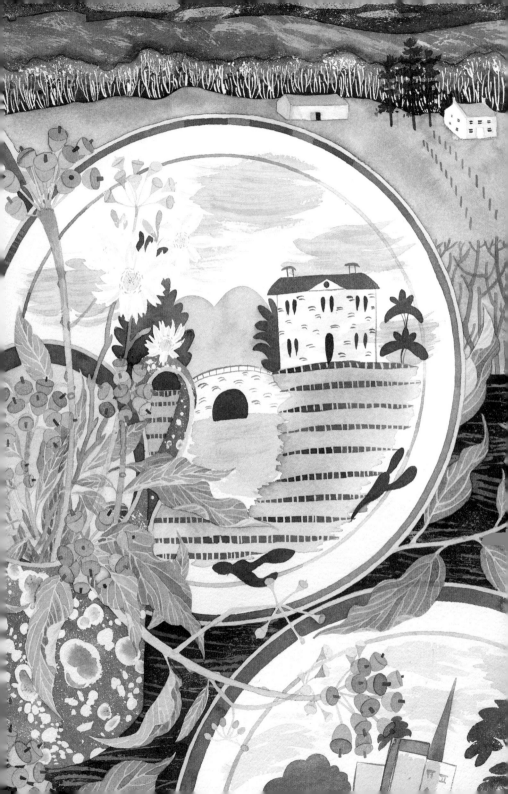

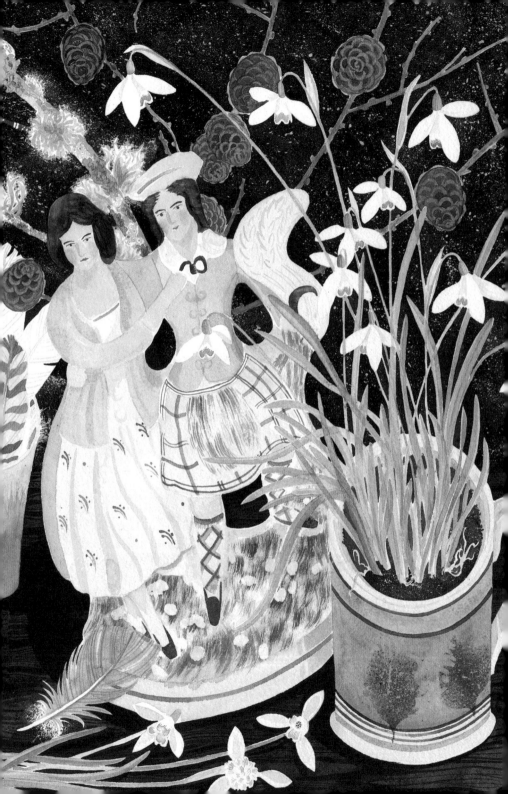

16

SNOWDROPS
Galanthus nivalis

Just when the year is at its darkest, when life seems to be at its lowest ebb; in the cold and the wet, when the earth has been drained of its colour, and all is brown and green and grey; just then, along mud-spattered verges, tucked under naked hedges, in sodden woods and snowy corners, the first snowdrops start to thrust their spear-like tips through the ground. Their shy, snow-white flowers may not be the showiest or the most colourful, but it's hardly surprising that they have become symbols of hope and quiet heroism, lifting the spirits at the most depressing time of the year.

Snowdrops look so completely at home here that it's a bit of a let-down to discover that they aren't actually native to the British

Highland Spring
Watercolour, 2020

Isles, and probably haven't even been here that long. They were first mentioned by John Gerard in his *Herball*, published in 1597, and they weren't described as growing in the wild until the 1770s (in Worcestershire and Gloucestershire), by which time they had presumably had a century or more to escape from gardens. Today the commonest species, *Galanthus nivalis*, grows all over the country, although its less widely spread in Scotland than in England and Wales.

Snowdrops are actually native to mainland Europe, from the Pyrenees to Ukraine, and they have a rather magical history. In the *Odyssey*, Homer says that Odysseus was able to break the spell cast by the enchantress Circe by clearing his mind with a plant whose 'root was black, while the flower was white as milk; the gods call it Moly'. It's a beautifully poetic passage, and over the years many plants have been suggested as a candidate, although of course Homer could well have made the whole idea up. Yet there's an intriguing story from Eastern Europe that suggests there might be more to Moly than it seems. In the 1950s, when Bulgaria was still part of the Soviet Union, a chemist called Dimitar Paskov, who had an interest in folk medicines, was intrigued to witness peasants in remote farming villages rubbing their foreheads with the leaves and bulbs of *G. nivalis*.

Paskov decided to do some research, and in 1956 he and his team were the first to isolate galantamine, an alkaloid that, as the Royal College of Physicians notes, 'is a competitive, reversible, acetylcholinesterase inhibitor that increases brain acetylcholine, a chemical of great importance in cerebral function'. That may sound baffling, but in practice it is anything but: scientific trials

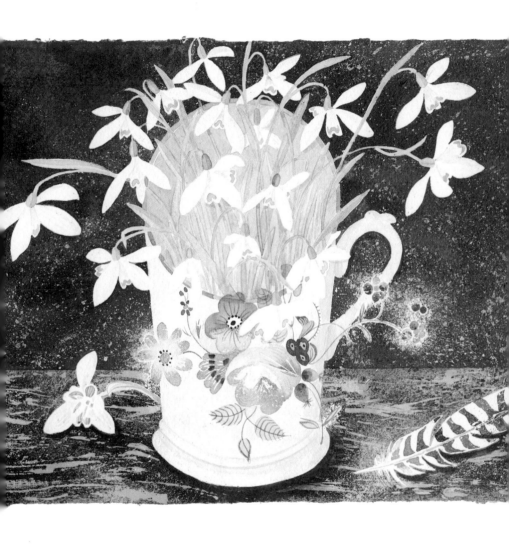

Snowdrops in Floral Cup
Watercolour, 2021

have shown that galantamine helps to improve memory for people with Alzheimer's and mild dementia, so perhaps Homer was right all along. Before rushing out and digging up the snowdrops in your garden, though, be aware that they contain only tiny amounts of galantamine; its much stronger clinical form is generally synthesized, and thus far licensed for use only in the USA.

Snowdrops are fascinating in other ways. They've evolved to flower earlier than most other plants, which means they have less competition for pollinators, and they've adapted to grow in cold conditions. Look at their flowers as they emerge from the ground, and you'll see that they're cleverly enclosed by two transparent membranes, which protect the delicate petals and meet above them in a hard, sharp point that can push through frozen earth and snow like a knife. Once the flower is safely clear of the ground, the membranes ('spathe valves' in botanical parlance) split apart to release it, then curl over the flower like a tiny shepherd's crook. In another adaptation to cold, snowdrop leaves and flowers contain proteins that act as natural antifreeze, enabling them to bounce back after an unexpected cold snap.

Then there's the green mark that decorates their three inner petals (technically tepals, but let's not get into the more confusing realms of botany). Like most such markings, these probably act as a form of signage for visiting pollinators, directing them towards the inner part of the flower, where the pollen and nectar can be found. Unlike most flowers, though, the green marks also help with photosynthesis, creating sugars that the plant can use in the production of seed – a useful trick in the short, dark days of winter when every ray of sunshine counts. And when the sun does

come out and temperatures rise above 10°C, the outer petals lift and spread, making it easier for pollinators to get inside.

Lastly, there's the way snowdrops spread their seed. Anyone who has visited a snowdrop specialist will know that the rarer garden varieties can command astonishing prices. This is partly a reflection of the time and effort it takes to breed new types, but it's also a function of the leisurely pace of snowdrop procreation. Presumably because there aren't many pollinators around when they come into flower, they rarely set much seed, and although their bulbs do increase in number over the years, that's generally a slow process too.

For the seeds they do produce, however, snowdrops have come up with a cunning strategy that, in theory at least, ensures they get scattered far and wide. When ripe (usually by May), the seed pods turn yellow and split open to reveal small, fleshy seeds with little curly tails, and it's these tails that hold the secret. They're called elaiosomes, a word that derives from the ancient Greek for oil and body, which describes what they are: oily bodies. These oil-rich structures are found in the seeds or fruit of about 3,000 different species of plant around the world, from snowdrops to celandines, and their purpose is to attract ants. The plant–ant relationship is very ancient, and almost as important as the relationship between plants and bees; it even has a name, myrmecochory. Elaiosomes are a striking example of what's known as convergent evolution, in which, over millions of years, completely unrelated plants and animals come up with the same strategy to deal with everything from seed dispersal to predators. In the case of snowdrops, the accepted wisdom is that, attracted by the nutrient-filled elaiosomes,

ants carry the seeds to their nests, often at some distance from the parent plant, and feed them to their larvae. Once the fatty elaiosomes have been consumed, the seeds themselves are discarded by the adult ants, often underground, giving them the perfect conditions for germination.

It's a brilliant adaptation, but the only problem is that there's virtually no solid scientific evidence that it actually works that way in nature. The one serious academic study that I've been able to track down notes that most elaiosomes are gobbled up by adult ants on the spot, and that there seems to be little or no evidence of seeds being carried back to the nest. That's not to say it doesn't happen, but it doesn't appear to be the win-win strategy that most accounts suggest. Still, if you see ants on your snowdrops in May, keep a close eye on what they're up to.

Snowdrops and Lichen Blue
Watercolour, 2023

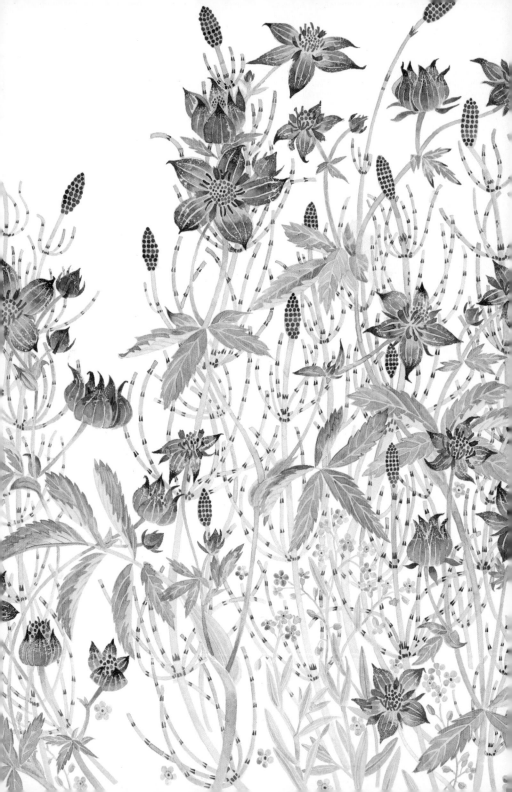

17

MARSH CINQUEFOIL
Comarum palustre

Widespread in wet places in the north and west of Britain, but much less common in central and southern England, marsh cinquefoil loves getting its feet wet, and its swollen roots help it to spread underground along the edges of ponds and streams. Its pretty maroon flowers have five petal-like sepals, and its leaves are also divided in five, which is where (via French) its common name comes from. The Latin name is a bit more confusing, since it was originally named *Comarum palustre* by Carl Linnaeus in 1753, then later renamed *Potentilla palustris*, before returning to its original name more recently. *Comarum* means 'hair' and refers to the fine hairs on the sepals, while *palustre* or *palustris* means 'of marshes'.

Marsh Cinquefoil with Horsetail (detail)
Watercolour, 2022

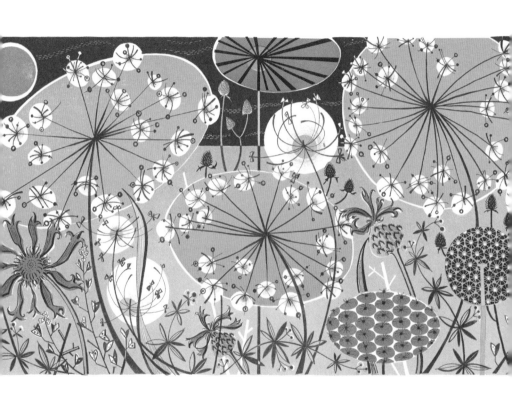

18

COW PARSLEY

Anthriscus sylvestris

I was brought up in Yorkshire, in a small village linked to other villages by country lanes and old drovers' roads, which in spring were always lined with a thick froth of cow parsley, its creamy white flowers rising above soft, ferny leaves. The young ash, beech and sycamore wood behind our house was full of cow parsley too, and as a small child one of my favourite pastimes was to create runs between their stems, connected to pressed-down nests below the flowerheads where they grew particularly tall.

Cow parsley may be common, but it's surely one of our most beautiful wild flowers. A native of Britain, it is also widespread in temperate zones across Europe and Asia, as well as the Atlas

Meadow II
Lithograph, 2008

Mountains of northern Africa. It spreads readily by seed, but also sends out swollen roots, or rhizomes, just beneath the ground, from which more plants can grow, so it's sometimes regarded as an invasive weed.

Cow parsley belongs to the carrot family, the Apiaceae, and is also related to alexanders, celery, lovage, dill and chervil, as well as such poisonous plants as wild hemlock and giant hogweed. Many of these look similar enough to be confusing, which may well be why one of cow parsley's common names is the somewhat sinister 'Mother die' – presumably a warning to children not to pick it or anything that looks like it.

The Latin genus name, *Anthriscus*, derives from the ancient Greek name for chervil, while *sylvestris* means 'of the woods', although when Linnaeus first gave cow parsley its botanical name, he used it in a more general way to mean simply 'growing wild'. As for its rather mimsy alternative common name, Queen Anne's lace, that seems most likely to be a nineteenth-century invention, and to have originated in the USA – although the name was originally applied to the wild carrot, *Daucus carota* (page 63), which like cow parsley had probably been introduced to North America the century before. Thus it could be regarded as one of Britain's more successful exports.

Morston Churchyard Sketch
Watercolour, 2003

Overleaf: *Speypath I*
Linocut, 2004

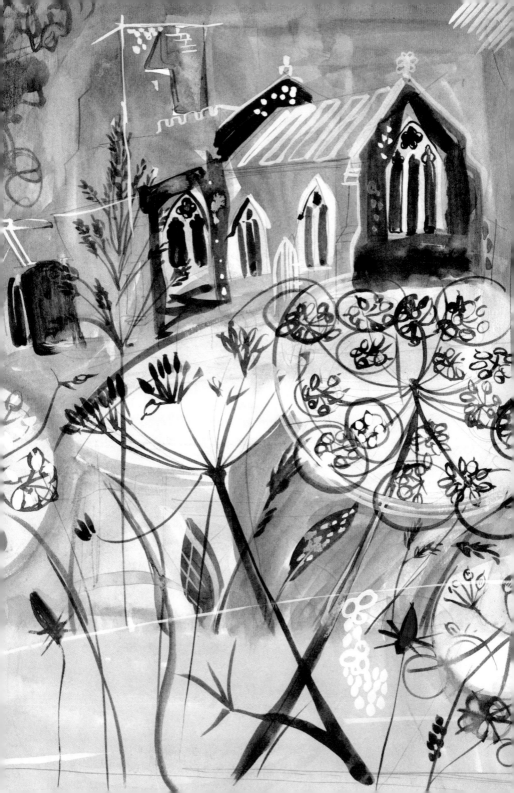

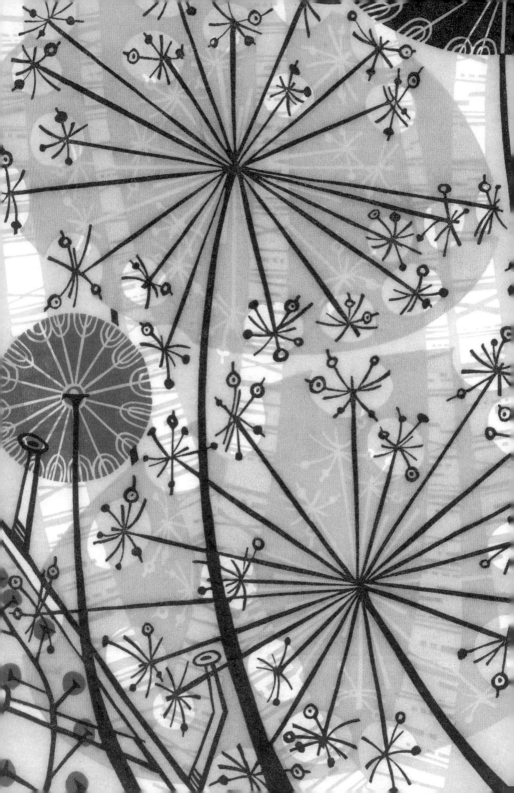

19

GOAT'S BEARD
Tragopogon pratensis

One of the many not-dandelions to be found growing in rough grass from Land's End to John o'Groats, goat's beard can be easily identified by its height – its flower stems can be a metre tall, and its seedheads are like giant dandelion clocks, although with fewer fluffy seeds. Look closely at its flowers, too, and they are quite distinct: its blunt-tipped petals are less numerous than those of dandelions; each anther has a little black blotch; and the entire flower is fringed by a starry ring of eight long bracts or calyxes with sharp points.

It might sound odd to talk about plant behaviour, but goat's beard also behaves in a distinctive way. Unlike dandelions, its flowers open only in bright weather, and close up entirely in the

Goat's Beard and Grasses
Linocut, 2016

afternoon, which is where one of its common names comes from: Jack go to bed at noon. Once closed, the pointed bracts enclose the flower, giving it a spear-like appearance. As for its Latin name, it's simply a transliteration of the common form: *tragos* means billy-goat in ancient Greek (which is also alleged to have given us the word tragedy), and *pogon* means beard, while *pratensis* means of the fields or meadows, which of course is where it usually grows. Goat's beard loves full sunshine and dislikes shade, so is seldom found in woods, although it's pretty tolerant of wind and salt spray, so it grows fairly happily on clifftops near the sea.

If you're desperate, goat's beard is edible, if not exactly delicious; its roots, grass-like leaves and unopened flower buds can be cooked or used in salads, just like dandelions (they have a similar milky sap). Yet while it might not be of much culinary interest, its close cousin from southern Europe is. White salsify – *Tragopogon porrifolius*, not to be confused with scorzonera or black salsify (*Scorzonera hispanica*) – looks like a prettily pink-flowered version of goat's beard, but its parsnipy tap roots, which can be 30 cm long, have been harvested since ancient times as a root vegetable. They have a sweet, delicate taste, which is often compared to oysters.

Goat's Beard
Linocut, 2003

20

YARROW
Achillea millefolium

With its flat-topped bunches of white or pinkish flowers and feathery, aromatic leaves, yarrow is one of the easiest wild flowers to identify, and one of the most widespread; it's found virtually everywhere around the world apart from Antarctica. It has a long and distinguished history in folk medicine, as two of its common names – woundwort and staunchweed – suggest. Its Latin name, meanwhile, refers to Achilles, who in the *Iliad* is described as treating his soldiers' wounds with a yarrow-like plant during the siege of Troy. As do those of many herbaceous plants, its leaves contain a host of chemical compounds to deter herbivores. Some of these appear to stimulate blood coagulation, while starlings have learned that they also inhibit parasites, and use yarrow leaves to line their nests.

Wild Garden II
Screenprint, 2009

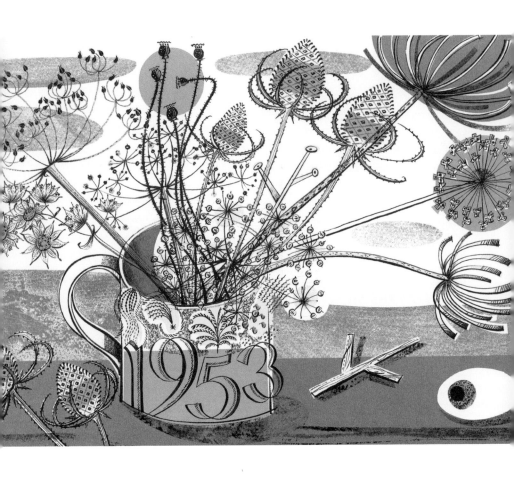

21

TEASEL
Dipsacus fullonum

With its striking pale blue rings-of-Saturn flowers and spiky, stiff leaves, the teasel is an easy plant to identify. It's also a remarkable success story, in an era when many wild flowers and wild animals are in decline. Until the 1960s teasels were largely confined to the south-east of England, but since then they have spread rapidly across the lowland regions of Britain and Ireland – mainly, it's thought, thanks to cars. Teasels thrive on the kind of disturbed ground found along roadsides, and they set prolific numbers of seeds, which are probably blown along in the wake of passing vehicles, helping them to spread far and wide.

There are two main kinds to be found in the UK: the common teasel, *Dipsacus fullonum*, and the so-called fuller's teasel, *D. fullonum*

The 1953 Coronation Mug
Lithograph, 2007

var. *sativus*, which is smaller and far less widespread. It's not yet clear whether fuller's teasel is a separate species or simply a cultivated form of the common teasel, since they can hybridize with each other and have the same number of chromosomes. Both have stiff, oval flowerheads formed of sharp spikes that protect the tiny blue flowers inside, but they have one small but important difference. Common teasels have straight spikes, but the spikes on fuller's teasels are stronger and bent at the tips, forming hundreds of tiny hooks.

It was this feature that made them, for centuries, an important commercial crop, their hooked spikes being used to raise the nap on woollen cloth. Originally imported from France, fuller's teasels were later grown on the north side of the Mendip Hills in Somerset, as well as in Gloucestershire, Yorkshire and Essex. They fell out of use in the twentieth century, although one or two firms still use them for brushing fine cloth, such as cashmere.

Strawberry Cup with Teasels
Watercolour, 2023

Overleaf: *Lakeside Teasels* (detail)
Linocut, 2013

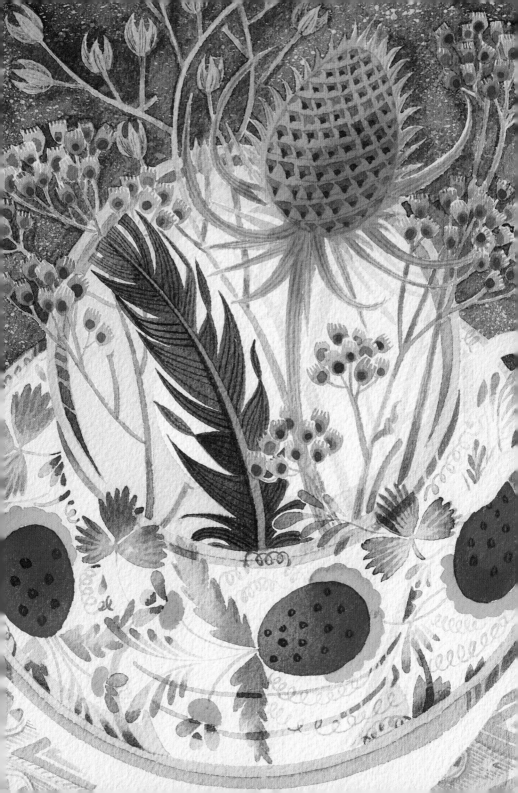

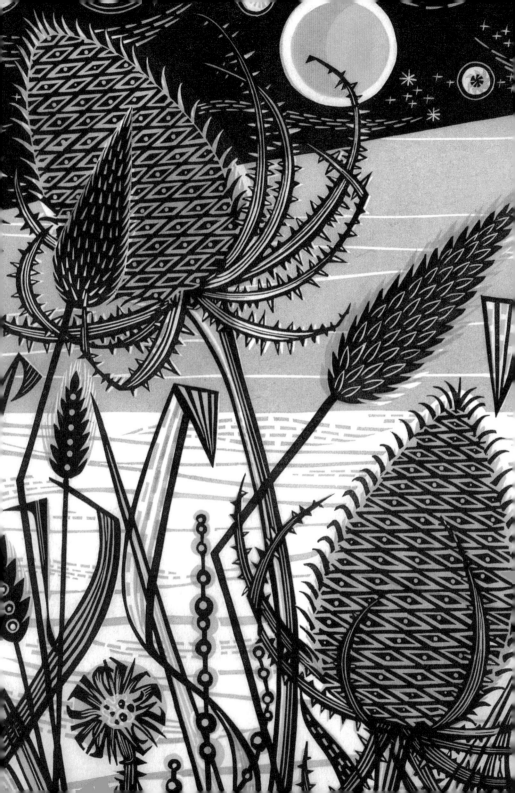

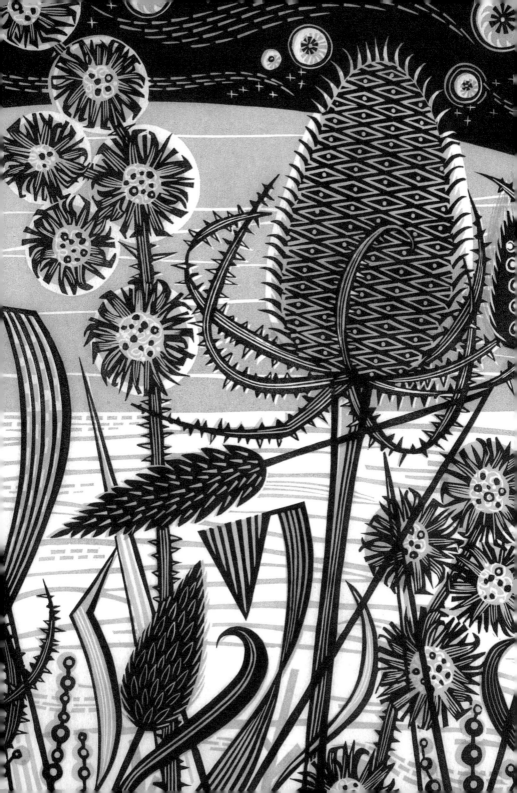

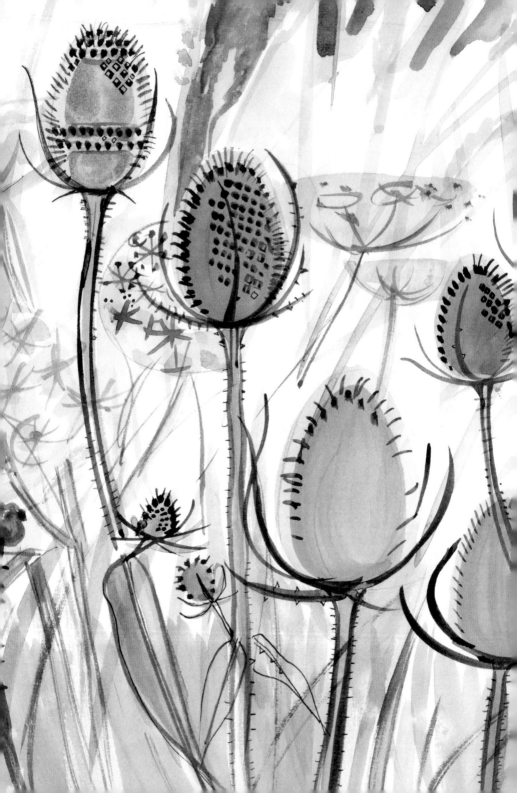

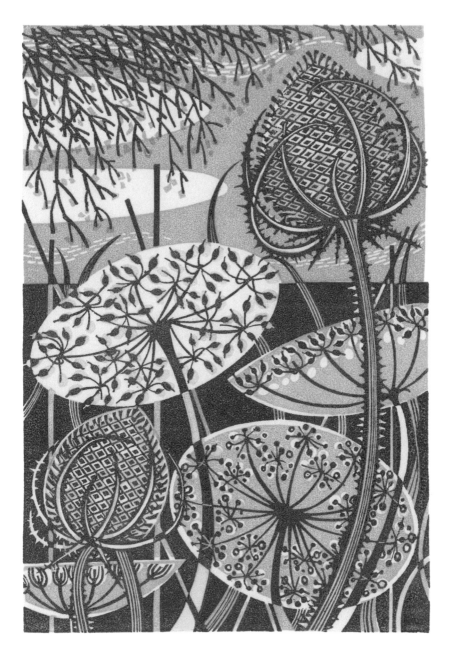

Norfolk Teasels

Watercolour drawing, 2005

Teasel

Wood engraving, 2006

INDEX

Page numbers in **bold** refer to main entries; those in *italic* refer to the illustrations.

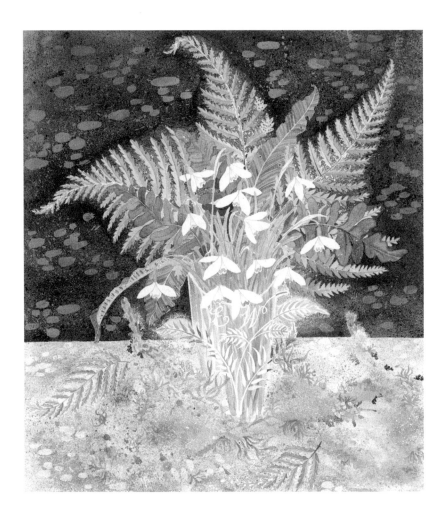

Snowdrops and Ferns
Watercolour, 2020